IMAGES
of America

DETROIT'S
MASONIC TEMPLE

On the cover: Please see page 41. (Courtesy of Greg Kowalski.)

IMAGES
of America

DETROIT'S
MASONIC TEMPLE

Alex Lundberg and Greg Kowalski

ARCADIA
PUBLISHING

Published by Arcadia Publishing
Charleston SC, Chicago IL, Portsmouth NH, San Francisco CA

Printed in the United States of America

Library of Congress Catalog Card Number: 2005938286

For all general information contact Arcadia Publishing at:
Telephone 843-853-2070
Fax 843-853-0044
E-mail sales@arcadiapublishing.com
For customer service and orders:
Toll-Free 1-888-313-2665

Visit us on the Internet at www.arcadiapublishing.com

CONTENTS

ACKNOWLEDGMENTS

The authors wish to thank Brother James A. Barber, executive director of the Masonic temple; Brother Richard V. Fritz, director of marketing for the Masonic temple; Brother John Snider; Brother Dr. Thomas W. Brunk; Brother Dennis Williamson, executive secretary of Scottish Rite Bodies; the temple engineering staff; and Joanne Sobczak, whose desire to see *The Phantom of the Opera* inspired this project.

INTRODUCTION

Nearly every city in the world, from London to Honolulu, hosts at least one Masonic lodge. A Masonic lodge is a body of men, joined by common obligations of character, belief, and friendship. It is a brotherhood of men working to better themselves by concentrating on the internal, rather than the external. Doctor and sweeper, captain of industry, and factory worker, president, judge, and trash hauler are joined by bonds of brotherhood.

In times of war, just as in ancient times, members of the craft met on high hills or in low vales. The locations where Masons met were as unimportant as the jobs and circumstances of their mundane lives. Yet, some of the meeting places, or temples, are grand edifices, jewels of their cities. Some are simple, sharing buildings that double as meeting places for the Boy Scouts and the local garden club. Others are grand.

The history of Masonry in Detroit dates back to the first French settlers in the 1700s. Over the years, they met in military forts, private homes, hotels, taverns, and, eventually, buildings owned for the sole purpose of hosting lodges.

Michigan Masons built the first Detroit Masonic Temple on Lafayette Street. The seven-story building featured a 750-seat auditorium, a banquet hall, and a library, as well as three lodge rooms. This was a significant building because it was the first in the state to be built with Masonic interests in mind. In just 20 years, the building was too small to serve the needs of the Masonic Temple Association, and a new temple had to be built.

The Detroit Masonic Temple is like no other, and it is the largest Masonic temple in the world.

Now, nearly 80 years after its construction, it still holds the title. There are more than 1,000 rooms comprising more than a million square feet. Aside from its six dedicated lodge rooms, one small lodge room, and one chapter, there are two functional theaters, two ballrooms, office space, dining halls, meeting rooms, and a kitchen large enough to feed thousands.

It is because the temple is unique that this book is by no means exhaustive. The challenge of compiling this book was as much a labor of what images to leave out as which ones to include. There are, easily, hundreds of rooms that have not been included here, but they do not stand out architecturally or are not significant to Masonry.

While unique in its scale and design, the Detroit Masonic Temple shares features common to every other Masonic temple in the world. Each lodge room has chairs, steps, altars, and seats in configurations identical to any lodge room.

A lot has been made over the years about the secrets of Freemasonry. Masons at the Detroit temple wonder how one can believe in a secret society when the same group owns a 14-story building. Masonry, with even a cursory glance, is anything but secret. Several of the nation's founding fathers,

numerous business leaders, entertainers, and politicians have been members of the fraternity. At a closer glance, the building itself is etched, carved, and painted with the symbols and trappings of the craft. The beehive symbolizes industry; the scythe represents time; the anchor signifies a well-grounded life.

The building itself was cast in the shape of a giant level, a Masonic symbol of equality. Almost every element in the building exists to signify or reinforce the very bedrock of Masonic teachings. The writings in the walls, the symbols carved into the banisters, and the construction of the lodge rooms all serve to remind and instruct the brethren about the promises they have made, the obligations they hold, and the correct ways to lead their lives—on the level, by the square, beneath a starry sky, and moving along the level of time.

While the temple was designed as the be-all and end-all of Masonic edifices, it was never truly completed. As soon as the two ballrooms in the basement were finished, they were used as venues for fund-raisers to complete the rest of the building. As time passed and the Great Depression set in, money became tight and construction halted. After raising and spending more than $6.5 million, money was still an issue.

And so, there is a third, unfinished theater on the top floor of the main tower. There is a pool that was never completed, a gymnasium that has never been used, and banks of showers and changing rooms that have never felt a drop of water.

The temple is very much like a European cathedral. There is delicate and intricate art in places not readily visible to the casual observer. The furniture is specific to the building, and there are handcrafted pieces within that do not exist elsewhere. The opulence of the building extends to nearly every area. The bathrooms on all floors, with only a few exceptions, are paneled in marble. The shower and changing areas in the gymnasium area are entirely made of marble.

Extreme attention was paid to detail, both on a minute and massive scale. The result is a building unlike any other in the world. Its scope is vast, yet it is intimate. It is overwhelming, yet it is inviting. It is a work of art, yet it is functional. The building is a fitting reflection of one of the most distinguished fraternities in the history of the world.

One

THE FOUNDATION

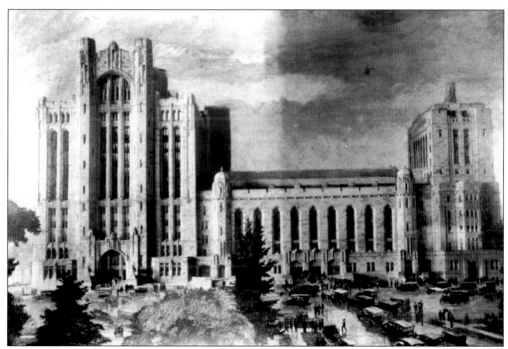

Shown here is an artist's preconstruction rendering of the temple as a completed building. This drawing includes the two mounted horseman statues intended to frame the main doors. The statues were never built. Many features planned for the building were never realized because of the economic impact of the Great Depression.

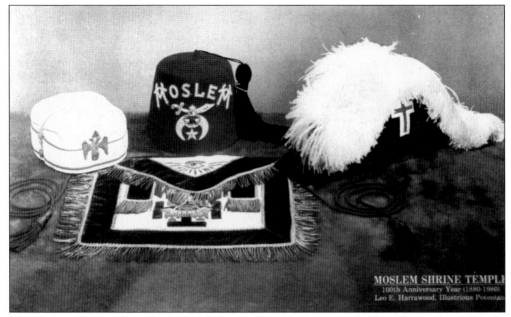

Masonic regalia stand on display, including a Scottish Rite cap (left), a Shrine fez, a Knight Templar chapeau, and a past master's apron (center). These items hearken back to the earliest days of the building when many lodges and groups used the facility. Even today, boxes of hats, medals, and other regalia can be found in storage and scattered through lockers in unused areas of the temple.

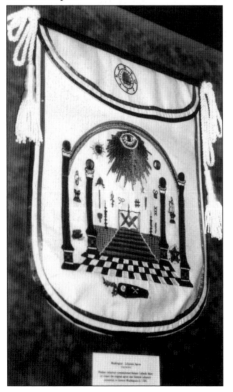

A replica of the Masonic apron worn by George Washington hangs on the Scottish Rite floor near Washington's painting. Washington was the worshipful master of his own lodge, and his personal trowel was used to lay the cornerstone of the Masonic temple as well as the United States Capitol building. A worshipful master is a democratically elected executive officer of the lodge.

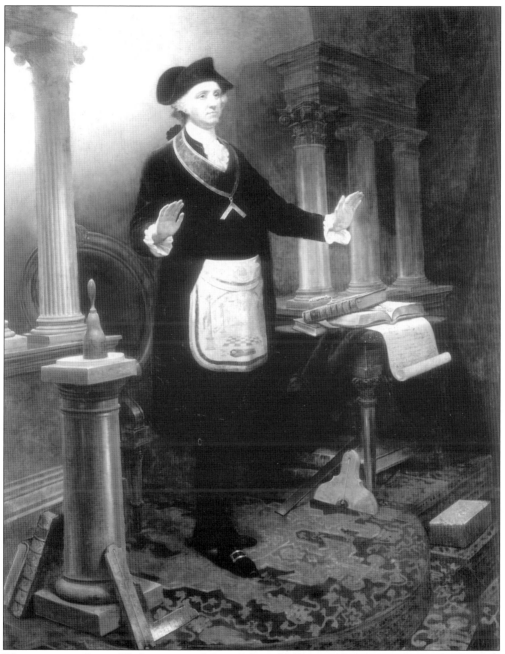

This painting, *George Washington as a Master Mason* by Emanuel Leutze, resides on the Scottish Rite floor of the temple. Leutze is best known for *Washington Crossing the Delaware*. Washington is depicted wearing the regalia of a worshipful master and is surrounded by the working tools of a master Mason. Not visible in this reproduction is the source of the light emanating behind him, a square and compasses. The Smithsonian in Washington, D.C., has asked to borrow the portrait for display, but issues of insurance and transportation have prevented the loan.

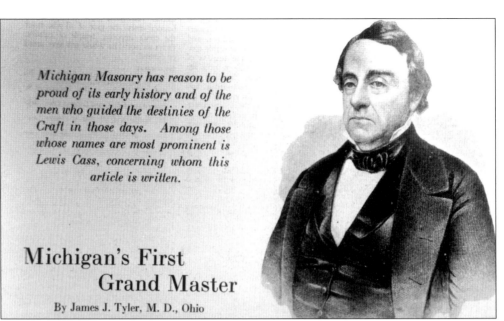

Michigan Masonry has reason to be proud of its early history and of the men who guided the destinies of the Craft in those days. Among those whose names are most prominent is Lewis Cass, concerning whom this article is written.

Michigan's First Grand Master

By James J. Tyler, M. D., Ohio

Like many prominent early Americans, Lewis Cass was a Mason. He also was governor of Michigan, governor of the Territory of Ohio, United States senator, candidate for vice president of the United States, and first grand master of the state of Michigan. The park across the street from the temple is named for him.

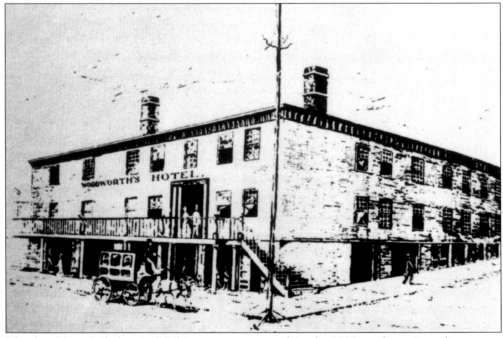

The first Masonic lodges in Michigan were convened in the 1700s and met in military mess halls and, eventually, in businesses like Woodworth's Steamboat Hotel at Woodbridge and Randolph Streets. Ben Woodworth's Steamboat Hotel was one of early Detroit's most notable establishments. Operated by "Uncle Ben" Woodworth, the hotel was a popular social gathering spot where one could imbibe pure Monongahela whiskey. It burned in 1848.

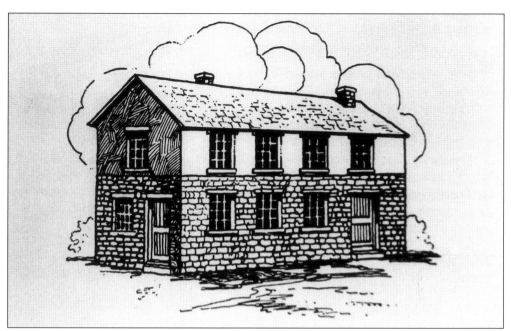

The Council House, located on the corner of Randolph and Jefferson Streets, became the first Masonic hall and served as a meeting place from 1826 to 1841. The Grand Lodge of Michigan was first convened there.

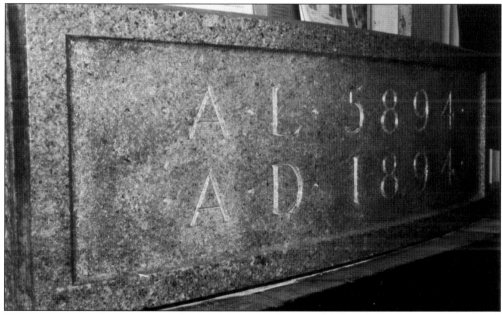

The cornerstone of the Lafayette Masonic Temple displays the date it was laid in *anno Domini* (in the year of our Lord) and Masonic *anno lucis* (year of light). The cornerstone now rests on the fourth floor of the temple. The laying of cornerstones dates to biblical times and has been an integral part of Masonic custom, tied directly to the carved stones that were put in place in buildings constructed by Masons through the centuries.

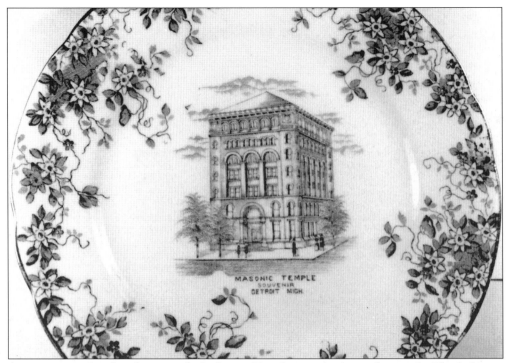

A commemorative plate depicting the Lafayette Temple is on display in the temple. The Lafayette Temple predated the current building and stood on Lafayette Street near downtown Detroit. The seven-story building cost $344,198 (in 1894 dollars), featured a 750-seat auditorium, a banquet hall, a library, and three lodge rooms. Just 20 years after construction, the building was considered too small to serve the needs of the fraternity.

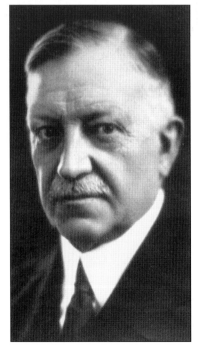

George D. Mason was a Mason and designed the temple with his firm, George D. Mason and Company. To this day, the ambitious design remains a marvel of architecture. With 1,037 rooms and encompassing 12 million cubic feet of space, the Detroit Masonic Temple remains one of the largest, most complex buildings in the world.

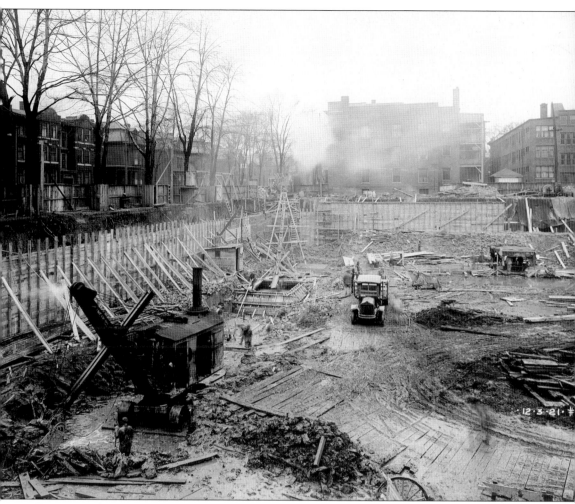

To service the mountainous building, gigantic tunnels were dug under the surrounding streets to accommodate steam, air, and water lines and electric cables. The tunnels, dug 34 feet below street level, were 10 feet wide. For fire protection, the Detroit Water Commission installed an eight-inch main from the line on Temple Street and a six-inch main from Second Avenue. (Photograph courtesy of the Burton Historical Collection, Detroit Public Library.)

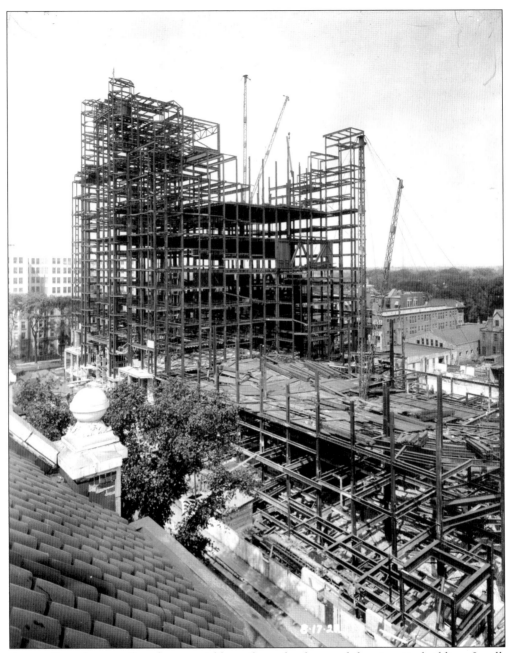

A complicated maze of steel rose quickly to form the frame of the gigantic building. In all, 16 million pounds of steel were used in the construction. In the main, or Ritual Tower, only four key columns ran from ceiling to roof. Other columns were staggered through the entire structure to distribute the massive weight. (Photograph courtesy of the Burton Historical Collection, Detroit Public Library.)

As the temple went up, businesses that specifically serviced the Masons promoted their products in *Detroit Masonic News*. With thousands of Masons expected to use the building, there was a huge market for items like the specialized costumes used during some Masonic ceremonies.

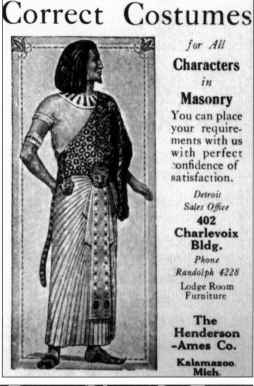
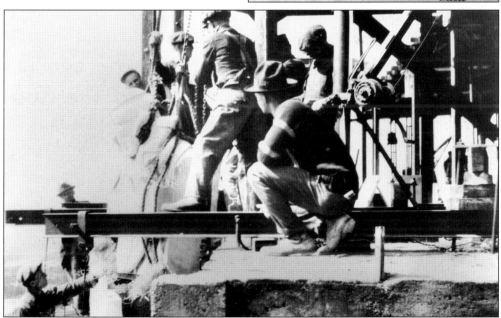

By today's standards, the construction techniques were primitive although quite effective. As the building rose higher above the surrounding streets, construction crews employed block and tackle to hoist the massive stones. Perched precariously on the edge of the facade, workers move a stone into place. Note that no one is wearing a hard hat nor are there any types of safety lines. (Photograph courtesy of the Burton Historical Collection, Detroit Public Library.)

At the time of construction, there were thousands of Masons in Michigan. Advertisers from all types of businesses put advertisements in *The Masonic News* honoring (and hopefully attracting the business of) those lodge members who would eventually meet in the building.

The Packard Motor Company also wanted its involvement in the building known. An interesting note to consider: these dump trucks working in the foundation predated four-wheel drive by decades.

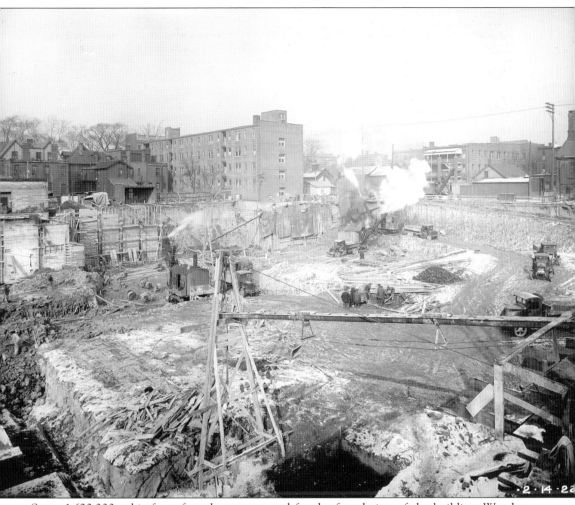

Some 1,620,000 cubic feet of earth was removed for the foundation of the building. Wooden planks were installed to form the foundation in preparation for pouring concrete. The foundation spanned 350 feet along the street initially and was expanded by an additional 50 feet. (Photograph courtesy of the Burton Historical Collection, Detroit Public Library.)

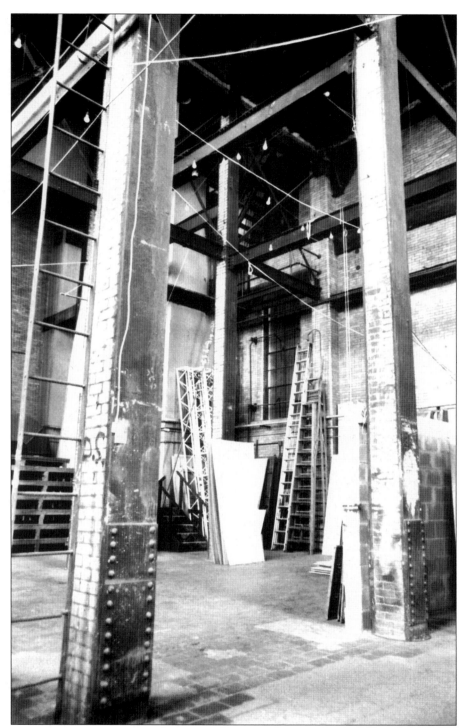

The innovative construction techniques still are evident in the building. Brick-filled steel supports rise high off the ground level to carry the massive weight of the huge swimming pool poised overhead. Although never complete, the main structure of the pool with its thick concrete form still exists, perhaps the first upper-floor swimming pool of its size ever built.

Even ball bearing manufacturers were
getting into product tie-ins.

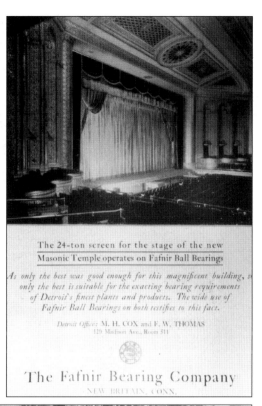

The 24-ton screen for the stage of the new
Masonic Temple operates on Fafnir Ball Bearings

*As only the best was good enough for this magnificent building, so
only the best is suitable for the exacting bearing requirements
of Detroit's finest plants and products. The wide use of
Fafnir Ball Bearings on both testifies to this fact.*

Detroit Office: M. H. COX and F. W. THOMAS
129 Madison Ave., Room 511

The Fafnir Bearing Company
NEW BRITAIN, CONN.

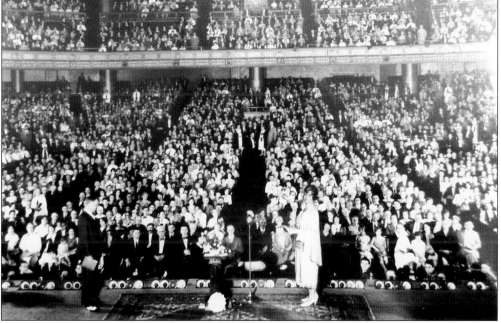

It did not take long for the facilities to be used by all manners of groups once it became available
to the public. This unidentified photograph dates from the early 1930s and may depict an awards
ceremony of some type using the main theater. Even to the present day, special ceremonies are
held in the theaters and ballrooms.

In keeping with its Gothic style, these stained-glass windows were installed in the Commandery Asylum.

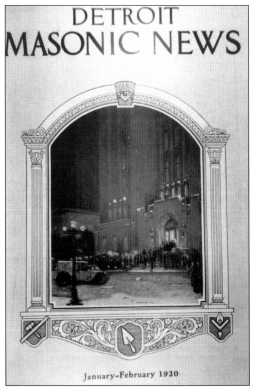

January-February 1920

Detroit Masonic News was a sophisticated publication designed for the Masons. Not surprisingly, the temple graced the cover of the publication many times over the years, depicting it in different seasons and in daytime and night views. It was recognized as a masterpiece of architecture from its inception and has been a source of pride for the Masons.

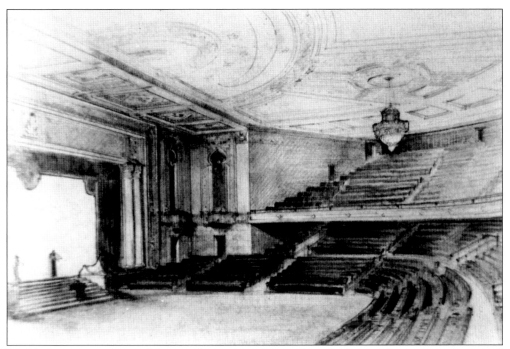

Well before construction of the temple was complete, its breathtaking style was being promoted with artist renderings in *Detroit Masonic News*. This work is of the main theater.

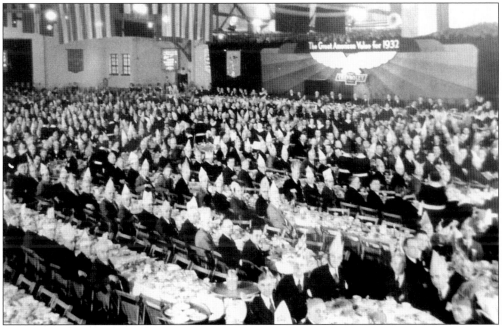

The sign on the back wall reads, "The Great American Value for 1932." Chevrolet was the product, and hundreds of sales people gathered for a luncheon on December 21, 1931, to face the new sales year. By then, Detroit was well under way to putting the world on wheels, and the Masonic temple was already recognized as a premier place for grand events.

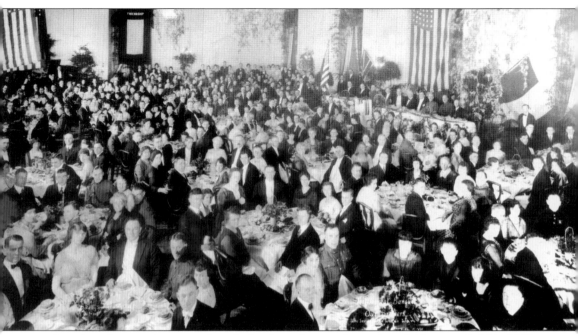

American flags set the tone as hundreds of people attend a testimonial banquet held in 1929 to honor "the brothers who served in the World War." The banquet was sponsored by their friends in Lodge 417, Free and Accepted Masons.

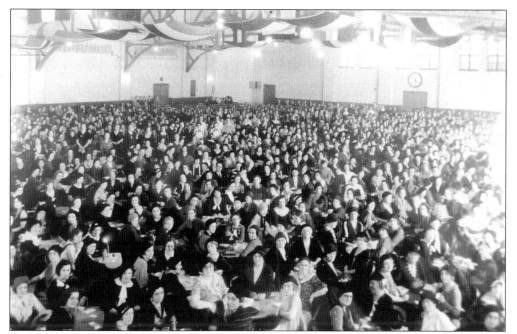

A mammoth bridge party was held in the 1930s in the vast open area of the Drill Hall. Hundreds of ladies participated in the event. This was before the huge trusses supporting the ceiling were covered with a dropped ceiling—the installation of which was an achievement in its own right considering its size.

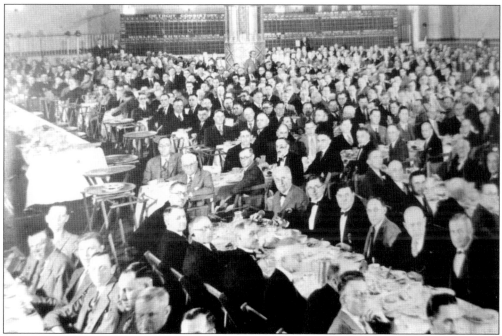

In May 1930, a champagne fund-raiser was held in the new temple to help pay off its debt. Construction began with an initial drive of $2.5 million donated by Masons. Total construction cost was $6.7 million. Note the vast scale of the room and the tote board in the background.

William Leslie Mitchell W. M.
259 Pilgrim, Highland Park 3 TO. 6-8698

Arthur F. Pritchard S. W.
30205 W. 6 Mile Road,
Box 141, Farmington Livonia 3427

Jimmie V. Wright J. W.
11094 Wayburn, Detroit 24 Prospect 5976

Gordon J. Symons, P.M. Treasurer
18300 Ferguson, Detroit 19 Vermont 5-4860

Arthur Rowe, P.M. Secretary
129 Florence, H. P. 3 Townsend 5-8184

William B. Francis S. D.
15751 Appoline, Detroit 27 University 2-1928

Henry O. Perry J. D.
15339 Roselawn, Detroit 21 University 3-3265

James M. Ivey S. S.
234 Pilgrim, H. P. 3 Townsend 6-7142

George A. Moreland J. S.
473 Peterboro, Detroit 1 Terrace 2-9654

Benjamin Nosanchuk Tiler
3202 Cortland, Detroit 6 Townsend 9-1975

John H. Menear, P.M. Marshal
190½ Pilgrim, H. P. 3 Townsend 5-5942

William Thomas Chaplain
16875 Manor, Detroit 21 University 1-6320

Alfred E. Benson Organist
482 Navahoe, Detroit 14 Lenox 0869

Leonard J. Hodge Associate Steward
16875 Manor, Detroit 21 University 1-6320

Edward A. Everett Associate Steward
3315 24th, Detroit 8

Frank B. Wiley Associate Steward
5438 Avery, Detroit 8 Tyler 7-0703

John A. Rohr Associate Steward
13422 Promenade, Detroit 5 Pingree 0154

Thomas H. Bailey, P.M. Chorister
190½ Pilgrim, H. P. 3 Townsend 5-5942

Frank Stringer Assistant Tiler
16731 Fuller, Detroit 21 University 2-7344

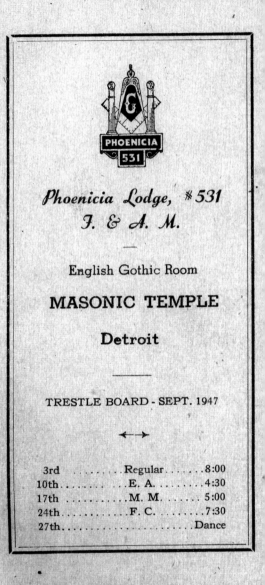

Phoenicia Lodge, # 531
F. & A. M.

—

English Gothic Room

MASONIC TEMPLE

Detroit

———

TRESTLE BOARD - SEPT. 1947

←→

3rd	Regular	8:00
10th	E. A.	4:30
17th	M. M.	5:00
24th	F. C.	7:30
27th		Dance

Through the years, the Masons produced their own publications in the temple. Although barely three by six inches, this served as a newsletter for the Phoenicia Lodge No. 531 and was issued in September 1947.

26

Dear Brothers:—

I hope you all have had a good vacation also a good time at the picnic. I would like to thank all the brothers who assisted us in putting it on also I would like to thank the brothers who donated prizes.

Well, here we are in September again and my year is slipping away fast and we have a lot of work to do. The first Wednesday, the third, will be our Regular at 8 o'clock. The second Wednesday, the 10th, First Degree. We will have 10 candidates, Lodge will open at 4:30 pm. sharp. The third Wednesday will be the Third Degree, Lodge will open at 5 p.m. The 24th, the last Wednesday, Second Degree. We will open Lodge at 7:30 p.m. sharp, so Brothers, you can see we have a lot of work ahead of us and I would like to see all of you come down and give us a hand. We will find something for all of you to do. On the 27th, that's our dance; I want to make that a big night. I hope you all got Brother Moreland's letter. I think it was a swell job so Brothers, I would like for you to sell your tickets as fast as possible and turn the money in to Brother Moreland so we will know where we stand. We will have one of our Brother's orchestra, Merle M. Alvey, so I know you all will like that.

Well Brothers; we have a lot of our own brothers sick, so if any of you live near those sick I would like for you to drop around and see them. You can find out from Past Master Sid Cocking as to who the sick brothers are. I wish them all a speedy recovery and hope to see them back at the Lodge soon.

The second Wednesday in October will be Past Master Tom Viant's night, so I would like to see all the past masters get out and give him a lot of support.

Brothers, I think I had better quit writing because it will be too long for the printer now so God Speed until we meet again.

Fraternally yours,
Wm. Leslie Mitchell, W. M.

Masonic newsletters are published by every lodge to keep members up to date on current business, upcoming events, and social news. They also help reinforce the sense of brotherhood among the Masons. They, in fact, commonly refer to each other as "brothers."

At the time the temple was built, it was not the only Masonic edifice in the Detroit area. The Detroit Masonic Country Club in Mount Clemens, on Lake St. Clair, was a year-round facility. It has since been sold. Many, if not most, prominent people in Detroit were Masons in the early part of the 20th century.

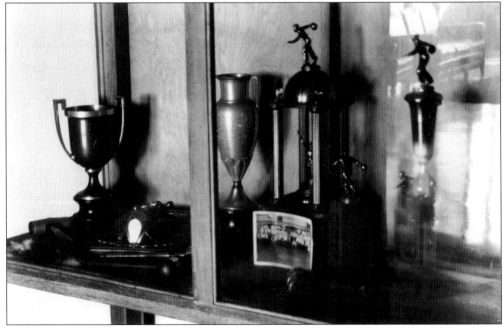

Masonic lodges fielded their own sports teams. These trophies were won by some of the bowling teams and remain on display in the temple. The trophies are representative of how active Masons were (and are) in society. Long viewed as a secret society by many people, the Masons actually take a high profile, and only Masonic ceremonies are closed to non-Masons. The temple was designed specifically to be used by the general public as well as Masons.

Two

STORIED WALLS

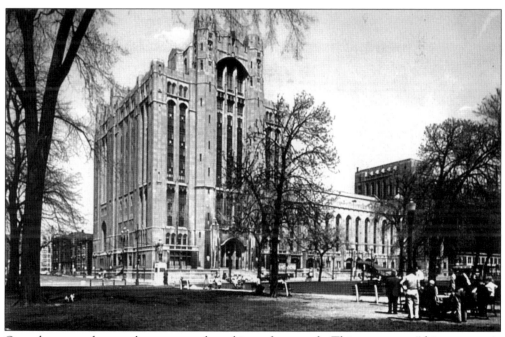

Over the years, the temple was a popular subject of postcards. This one notes, "this structure is unparalleled among those structures devoted to the Masonic purposes." The facade has changed little over the years.

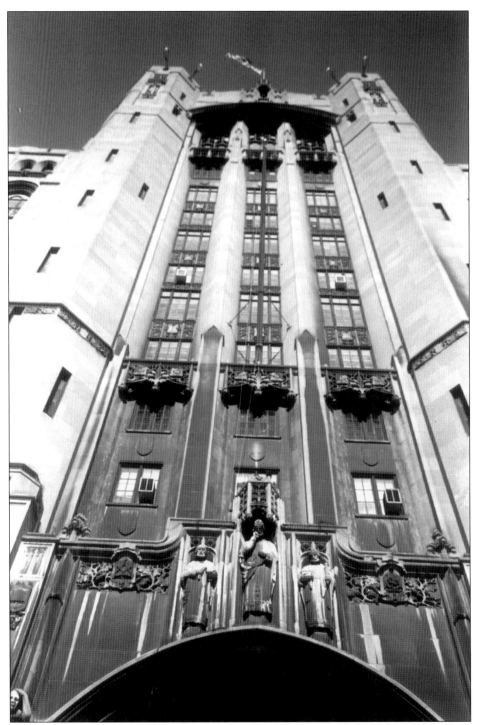

The front face of the temple features the imposing figures of Hiram, king of Tyre; King Solomon; and Hiram Abif, the grand master of the building of King Solomon's Temple. Despite the incorporation of many styles and cultural themes, the temple is overall a Gothic structure. It pays tribute to the Masonic roots in stonemasonry and is made principally of Indiana limestone.

The lancet Gothic windows on the south side of the building are highly ornamental and filled with rich detail. Virtually every inch of space was given an artistic treatment.

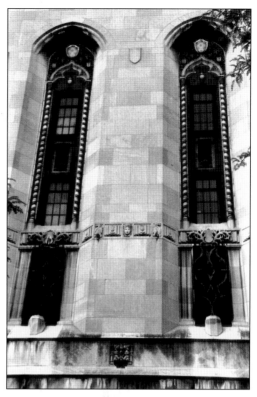

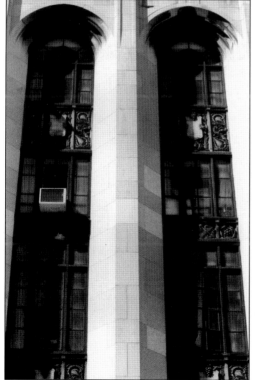

Another set of Gothic windows adorn the side of the main tower. Traditionally, Greek or Egyptian stylings were used for fraternal buildings. But because Masons are so closely associated with the medieval stonemason guilds, the Gothic style most closely embodies the culture of Freemasonry.

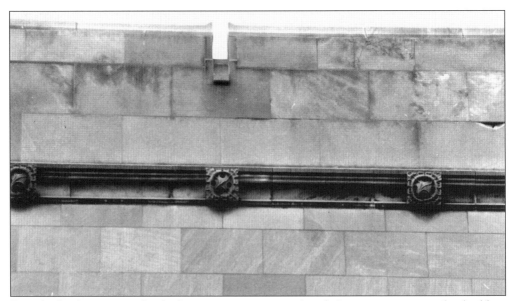

Even high above street level, decorative trim is employed. In many respects, the building resembles a medieval Gothic cathedral. Architect George D. Mason noted, "Quite early in the consideration of the exterior, a decided preference for the Gothic was evident and was expressed both by the committee and the general public . . . The spirit and tradition of the Knights Templar was unquestionably Romanesque or Gothic and operative Masonry having its origin in the guilds of Europe had the tradition of the great cathedrals of which they were the builders."

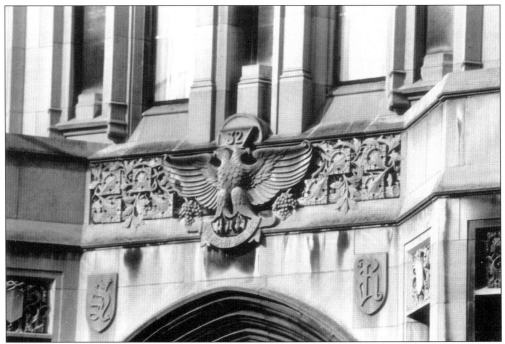

The double-headed Eagle of Lagesh, emblem of the Scottish Rite, stands over the west side door. The Latin inscription is *Spes mea in Deo est* (My hope is in God). The eagle, or storm bird, was the symbol of the ancient Babylonian city of Lagesh and is a proud symbol of power.

The Ritual Tower rises some 210 feet above street level. This view is from the fourth-story balcony. Although it is not easily accessible from within the building, it presents a dizzying view over a low wall.

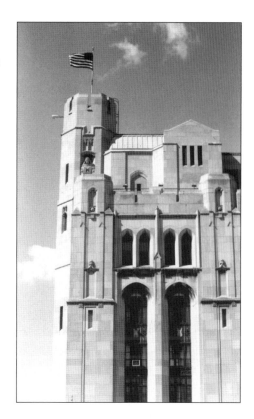

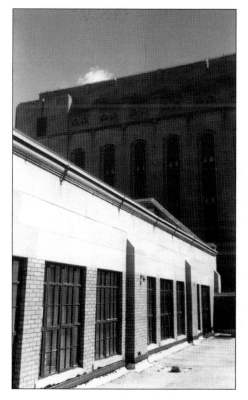

The fourth-floor outdoor balcony is not open to the public, but it played a key role in early automobile shows that were held inside the temple. Cranes hoisted the cars to this level, and a special ramp was used to bring them into the Drill Hall where they were put on display. It may have been the only time an automobile show was presented on the upper level of a major building.

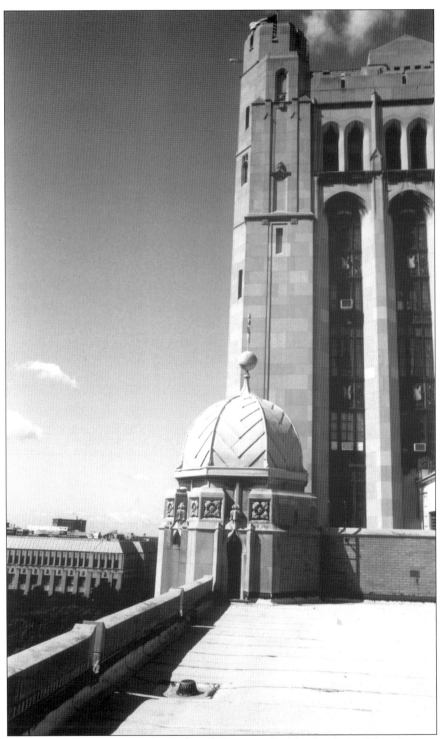

The ornamental cupola on the fourth-floor balcony is highly detailed, although most of its intricate styling is not visible to the public. In all, 100,000 cubic feet of stone from the quarries of Indiana were employed in the building.

Carved stone panels decorate the side of the dome. Many Masonic temples are topped with domes, which hearken back to the Temple Mount at the Dome of the Rock in Jerusalem, a sacred site to Christians, Jews, and Muslims.

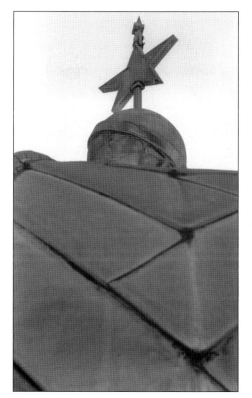

The copper dome is topped with a five-pointed star. That carries the symbolic geometric representation of the golden ratio, a mathematical equation of measurement. A great deal of lore is associated with the five-pointed star, and the related pentagram, which has many connotations, including witchcraft and demonology. Masons note clearly that they have no association with those practices whatsoever, but anti-Masons have tried to link them with that connotation. Medieval Masons considered the star a symbol of wisdom.

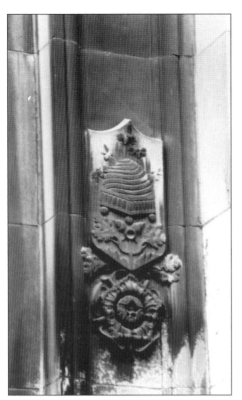

A non-Mason likely would be mystified by the symbol of a beehive carved into a plaque on the front of the temple. In fact, the motif is repeated indoors too, as it symbolizes the honorable trait of being industrious.

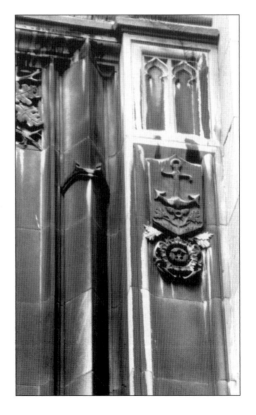

Another panel on the front of the building features an anchor, which is the symbol of a well-grounded life. It is said that all the meaning of Masonry can be found on the walls of the building—if one knows where to look and how to interpret what one is seeing.

Carved symbols abound on the building, although most are overlooked by people passing by. Yet, each symbol carries a story. This niche is for a statue that was never installed. Below is an image of the entered apprentice.

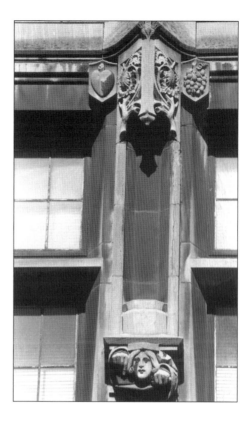

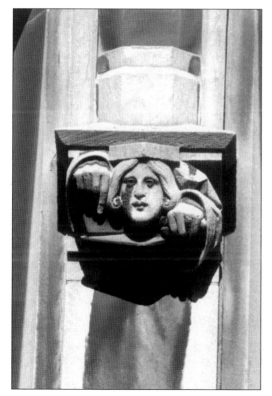

The entered apprentice is the first degree a candidate is given in a Masonic Blue Lodge. As the worker who did the least thinking and most grunt work, he occupies a small, obscure place on the facade of the temple.

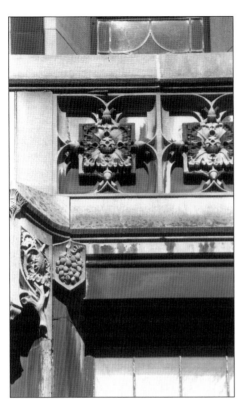

Symbolism blends with whimsy in the ornamental carvings, as shown in these leaves and grapes. At the time, it was common to decorate all manner of buildings with decorative carvings, and not all carvings carried special meanings.

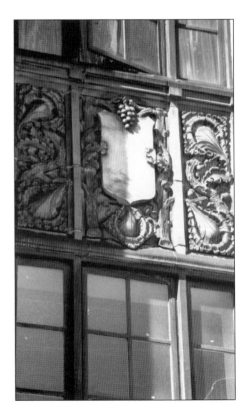

A swirl of leaves and grapes surround a shield separating banks of windows.

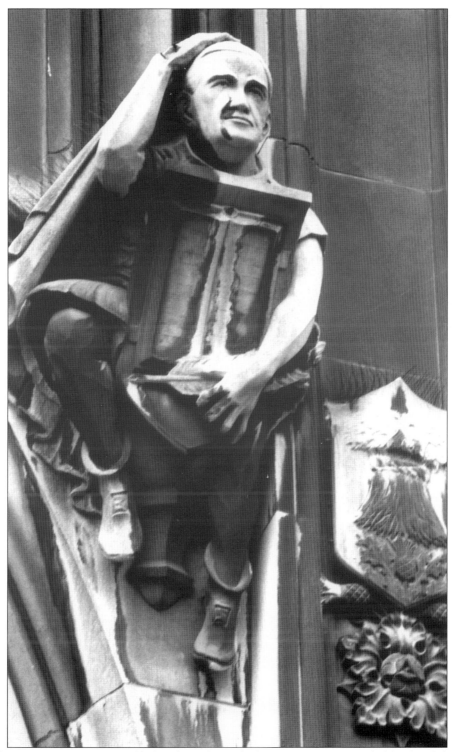

Architect George D. Mason takes his place alongside the main entrance. He holds a trestle board, which in Masonic lore is where the master lays out the work for the laborers to complete.

This rooftop finial-style element is virtually invisible from the ground level. It stands at the front of the building.

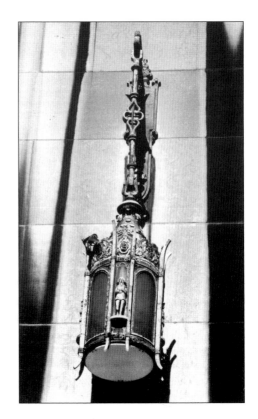

An ornate light hangs alongside the front entrance. Like all the fixtures in the building, it was specially created for the Masonic temple.

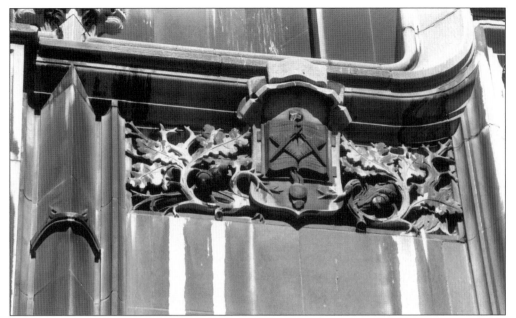

The square and compass are the most identifiable and most central of all Masonic symbols. They were the principal tools used in stonemasonry work, and despite their simplicity, they were fundamental in the building of the Gothic cathedrals of Europe, some of which, today, remain among the greatest buildings ever created. That innovative spirit and skill are reflected in the Masonic temple.

Architect George D. Mason makes another appearance on the building front, next to an hourglass, symbol of man's mortality, and a book, symbol of a volume of sacred law. He carries a representation of the temple in his arms.

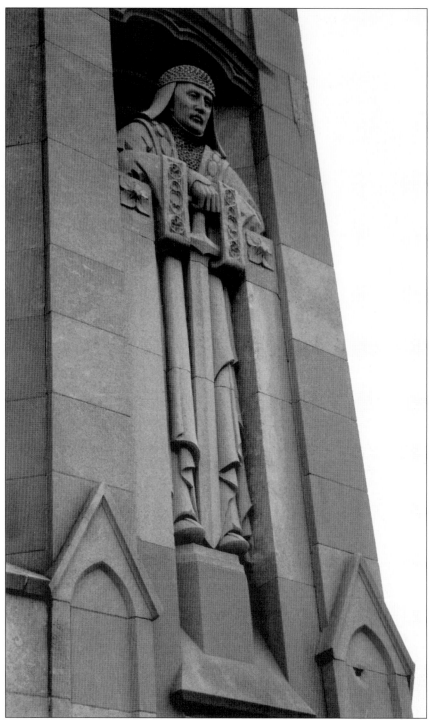

Gigantic, yet easily overlooked, a knight stands high above the street level. There are four knights of the Crusades on the Ritual Tower. The knights may be the largest sculptures in the city. They were created by sculptor Henry Steinman, working out of the Detroit studio of New York sculptor William F. Gurche.

Imposing knights peer from around a turret high above. The massive knights are lordly when viewed from close up but are easily missed from below.

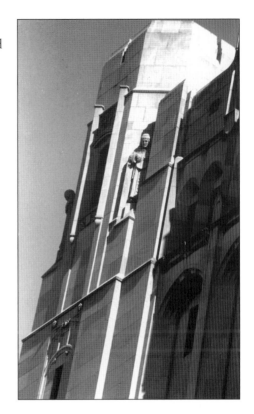

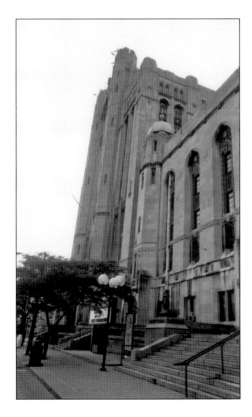

Most people visiting the temple pass through the main entrance—usually without noticing the architectural wonders around them.

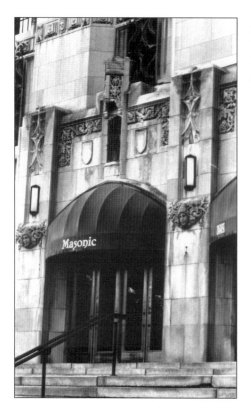

Carved faces and artistic flourishes surround the ticket office entrance where people get their tickets for leading Broadway shows, European productions, and musical acts.

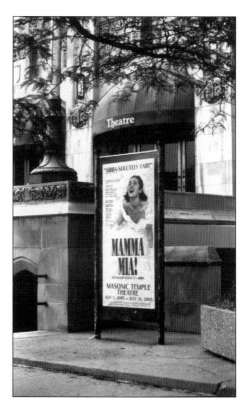

Mamma Mia! has played at the temple's main theater several times. Its vast stage and large seating capacity make it a superior venue for shows. Many major Broadway productions have played at the Masonic theater.

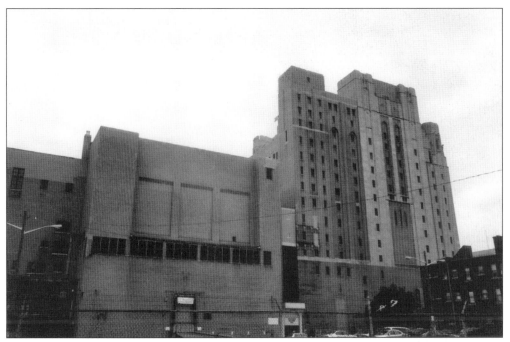

Massive and dramatic in its own right, the rear of the building has a more industrial appearance. Most people see only the impressive front of the building.

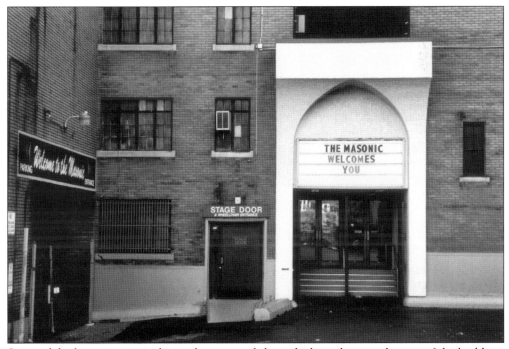

Some of the biggest stars in theater have passed through these doors at the rear of the building. The stage entrance provides easy access to the rear of the building near the main theater. Inside are 23 dressing rooms serving both theaters.

The Masons' sense of history is not limited to their own extensive past. This mural on the back of the building was done in a historic style. It actually was commissioned in 2005.

Three

WITHIN THE WALLS

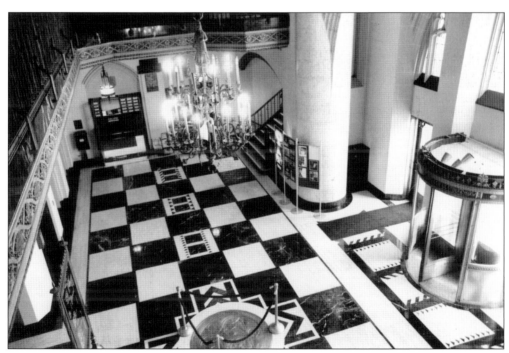

The main lobby was inspired by a castle in Sicily and is dazzling, as seen from the first floor mezzanine. The black and white tiles are emblematic of life, checkered with good and evil. The main lobby was designed by master architectural sculptor Corrado Parducci. Parducci (1900–1981) was a distinguished architect who worked on many of Detroit's most memorable buildings, including the Penobscot Building, Buhl Building, Guardian Building, and the Shrine of the Little Flower in Royal Oak.

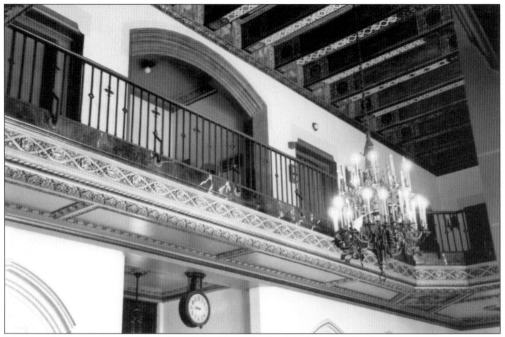

The first-floor mezzanine skirts the lobby. Note the highly decorated rafters. Architect and artist Corrado Parducci attended the Beaux-Arts Academy of Design and was also influenced by the art deco movement, although that is not evident in the Masonic temple.

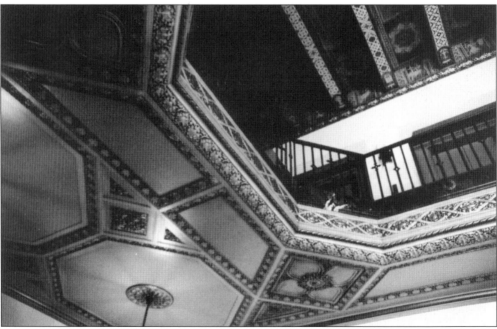

All areas are canvasses for artistic details, even the underside of the first-floor mezzanine. A testament to the quality of the construction is shown in that the building looks virtually new in most areas. Few structural cracks are evident anywhere, and most ornamental features are in excellent condition, except for a few traces of wear.

The Crystal Ballroom lives up to its name with its glittering chandeliers. The ballroom features balcony seating as well as room for 750 people. Located on the first floor, it is a popular location for wedding receptions.

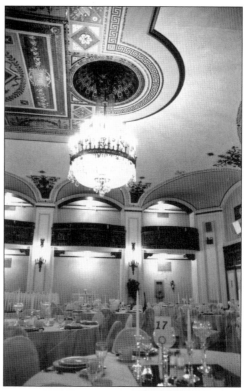

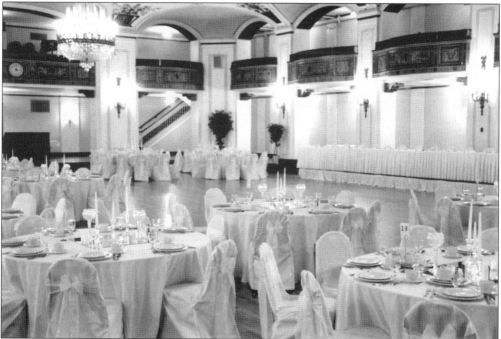

The Italianate-style Crystal Ballroom covers 9,550 square feet of space and can accommodate 500 for dancing. It is served by a massive kitchen just down the hall. And there are five dining rooms next to the main ballrooms.

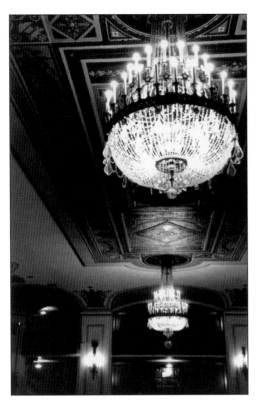

The Crystal Ballroom chandeliers glitter like diamonds. They have been landmark features of the temple since it was built. An early Masonic publication refers to the ballroom as "unquestionably one of the most beautiful rooms in America."

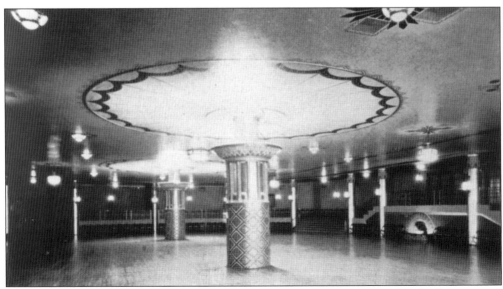

Here is a view of the Fountain Ballroom shortly after the temple was completed. The Fountain Ballroom is so named for the small fountain at right. The room is one floor up from the Crystal Ballroom, and both are below street level.

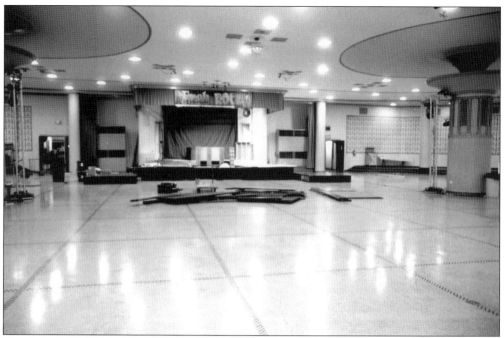

The Fountain Ballroom is vast and can accommodate seating for 1,800. For years, the Fountain Ballroom had a hardwood floor. It was recently removed, and the original marble floor beneath it was restored.

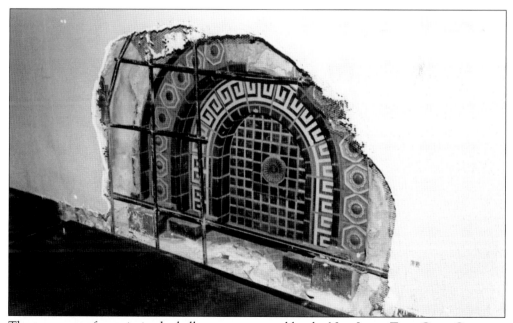

The terra-cotta fountain in the ballroom was created by the New Jersey Terra Cotta Company at a cost of $8,659. It was partially removed and sealed over when alterations were done to the ballroom in 1950. In recent years, the fountain was located and revealed from behind its wall covering. So impressive is the room that it was called "the showplace of the Temple" in the November 1926 issue of the *Masonic News*.

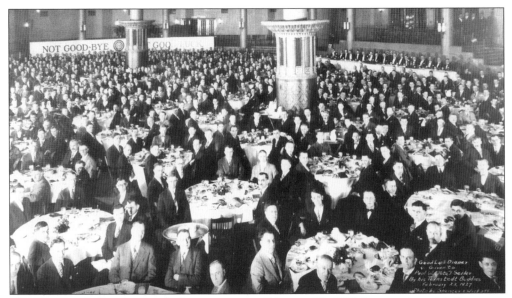

The Fountain Ballroom is packed to capacity on February 23, 1927, for a testimonial dinner.

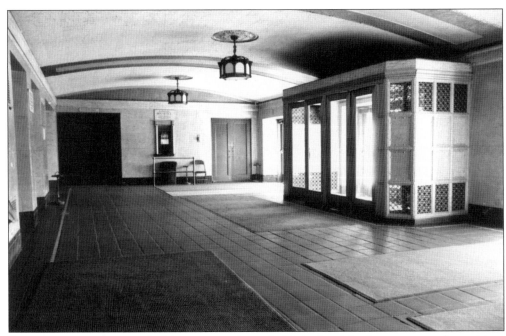

Say one is going to go to the Masonic temple, and this is the sight that most people envision. This is the lobby of the main theater, which is the only part of the building that most people see. The main entrance is rather plain in comparison to the rest of the ornate building.

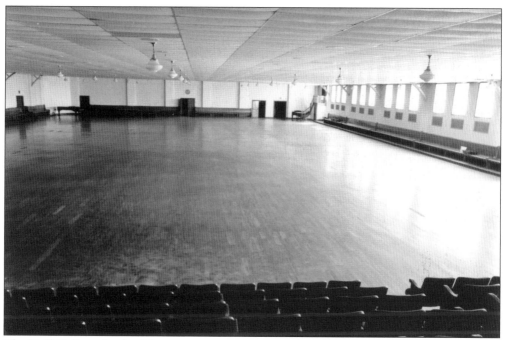

The Drill Hall on the third-floor mezzanine is an astonishing feat of engineering. Encompassing 17,500 square feet of open space, the hall was once used for automobile shows as well as drills by uniformed bodies of the Commandery, Consistory, and Shrine Patrol.

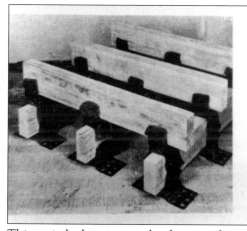

Stevens System of Sound and Vibration Control

The question of Sound-Proofing in connection with Masonic Temples is something that is receiving greater consideration than ever before, as the transmission of sound, due to the presence of lodge halls, organs, blowers, motors, bowling alleys, etc., in our modern Masonic Temples creates a condition where the control of such sound emanating from these sources has to be considered.

The "STEVENS SYSTEM" of Sound-Proofing has been used under the large drill floor and motor generator sets in the Detroit Masonic Temple, and has been used in many other Temples throughout the country.

This System of Sound-Proofing has absolutely proven successful all over the country, and we stand ready to prove our contentions by actual installations. Our engineers are ready to make detailed suggestions and recommendations at all times, and we can demonstrate the practicability of our theories.

Stevens Sound-Proofing Company

407 SOUTH DEARBORN ST., CHICAGO, ILLINOIS

This period advertisement by the manufacturer shows the special construction of the "floating floor" of the Drill Hall. It consists of interspersed layers of wood and felt, topped with pine. The arrangement dampens the sound of the marchers and softens the floor with a little "give," reducing vibration and easing the strain of marching on a hard surface.

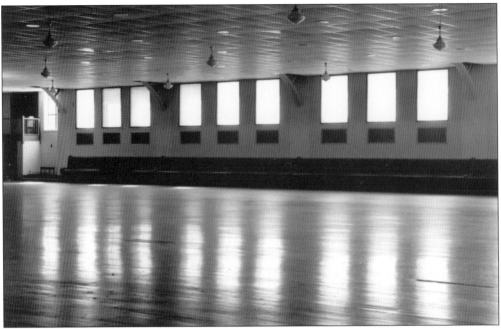

The Drill Hall is the unofficial practice space for the Radio City Rockettes when they come to perform in Detroit. The dropped ceiling was added in 1985, covering the large spanning trusses. The trusses allowed the ceiling to be supported without any columns interrupting the vast floor space.

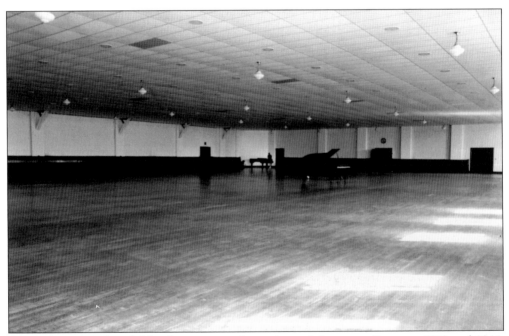

A grand piano is dwarfed by the immense dimensions of the room. Between 1942 and 1944, servicemen were housed here while attending aircraft engine maintenance school.

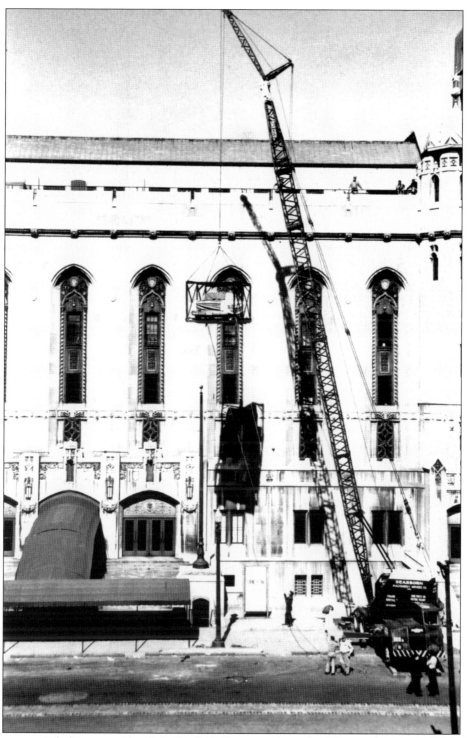

The open-air balcony outside of the Drill Hall was used as a loading site for cars presented in early automobile shows. Cranes hoisted the cars to their lofty perch, and they were then moved inside for the shows.

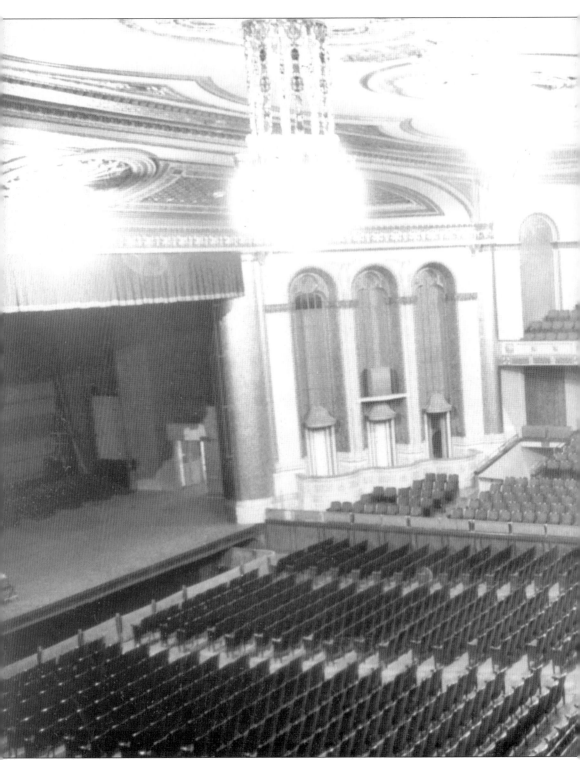

In keeping with the scope of the rest of the building, the main theater has epic proportions, with seating for 5,000. Done in a Venetian Gothic style, the auditorium boasts chandeliers that are

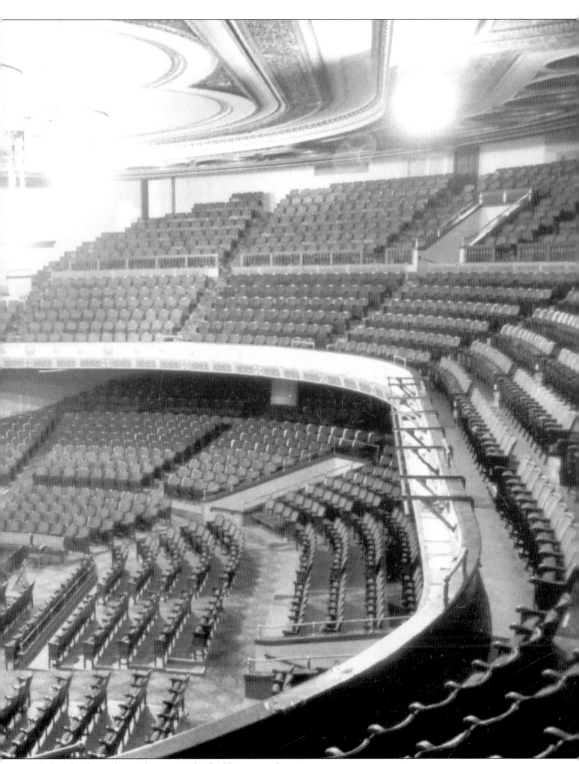

13 feet high and weigh one and a half tons each.

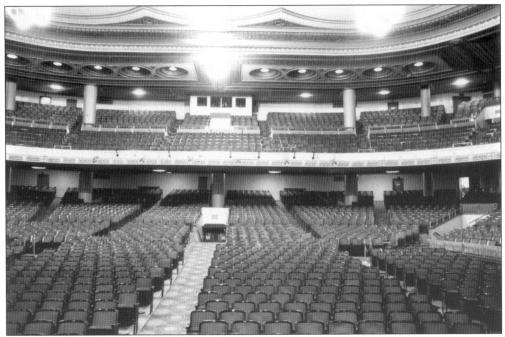

The performers' view of the theater can be intimidating as it stretches into the distance. The theater's size makes it capable of handling even the largest shows.

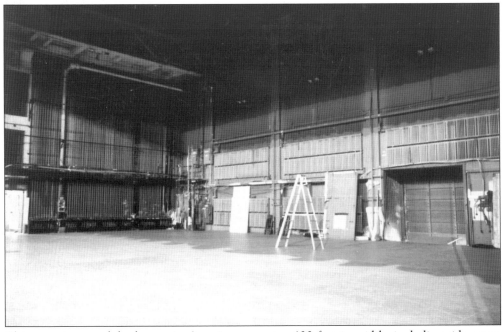

This stage is one of the largest in America, spanning 100 feet in width, including side areas, and 55 feet in depth back from the curtain. A vast array of some 90 sets of controlling lines was installed to manipulate backstage items.

Box seats flank the stage, and the entire setting is highly decorated, making the theater a performance in itself.

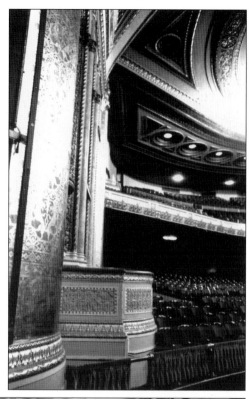

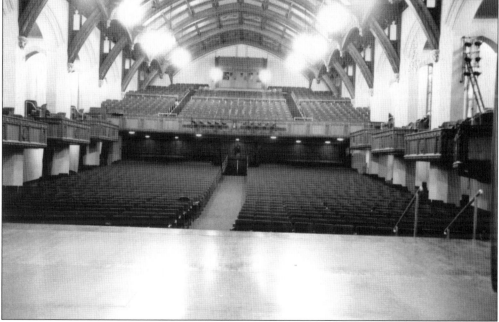

Just a short passageway from the back of the main theater is the door to the stage of the adjoining Scottish Rite Cathedral. With about 1,600 seats, it is smaller and more intimate than the main theater. It is especially popular with musical groups, such as the White Stripes. The stage is 64 feet across and 37 feet deep.

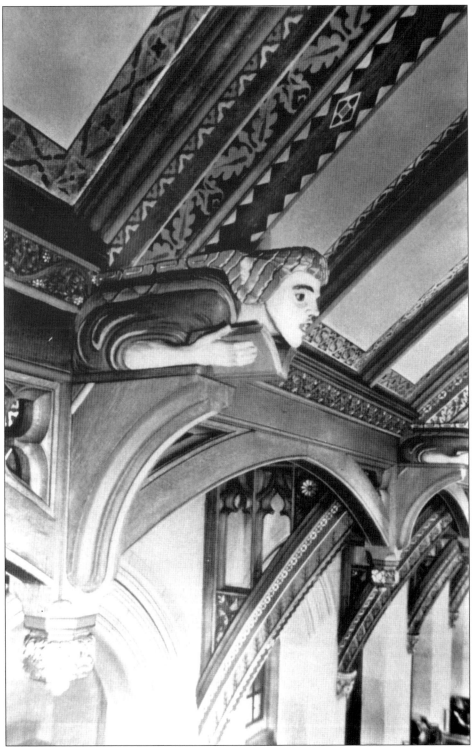

High above the seats, an angel extends from the wall. The theater was also designed as a staging area for dramatizations of Scottish Rite degree ceremonies.

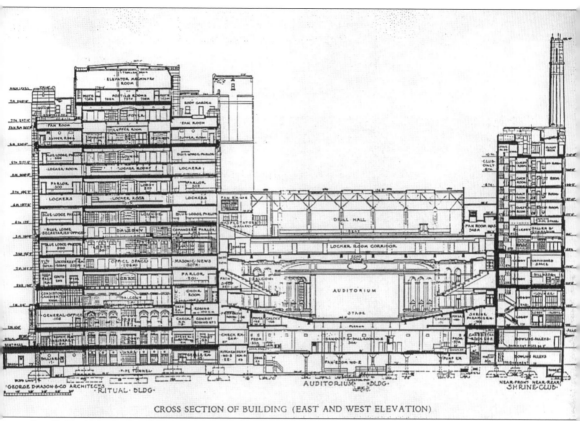

CROSS SECTION OF BUILDING (EAST AND WEST ELEVATION)

Small five-by-seven-inch booklets of architectural designs like this cross section are available at the temple for a small charge. This gives an indication to the complexity of the design, spread over its many floors. The most prominent feature visible here is the main theater, or "auditorium."

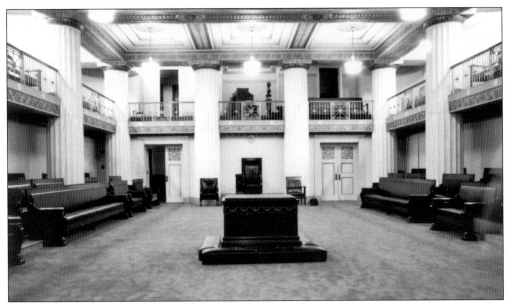

The Greek Doric room is seen from the east. The lodge rooms are a remnant from the medieval past when stonemasons were considered "free" workers because they were not bound to the land. They went from town to town to build great structures, and they needed lodging near the construction sites—hence the lodges. The origin of the term Freemason is not entirely clear, however, and might refer to the fact that stonemasons were not taxed for working in churches or monasteries.

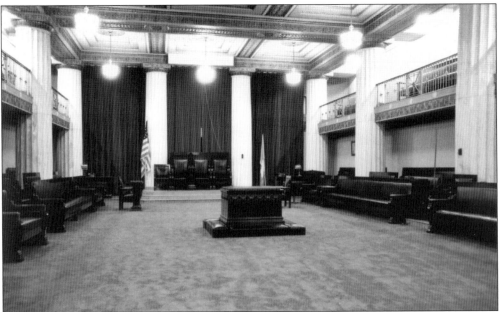

The Greek Doric room is seen from the west. All the lodge rooms were done in different classic architectural styles, with a notable feature that none have any windows. That ensures privacy. Even in the earliest American lodges, where Masons often met in buildings that served other uses, the brothers held their ceremonies on the second floor, above prying eyes. Masons say they are not a secret society, but rather a society with secrets.

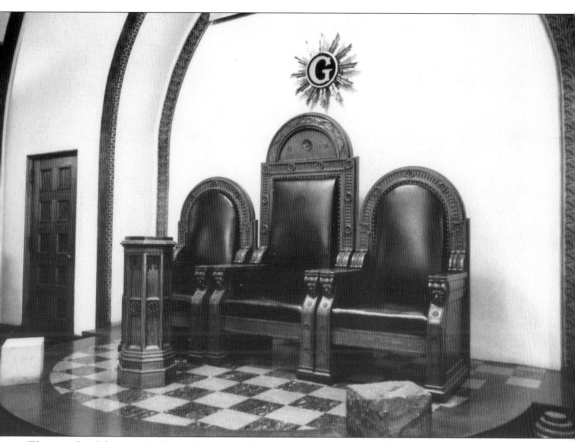

The worshipful master's chair dominates the Romanesque room. The woodwork in the room came from an old temple building.

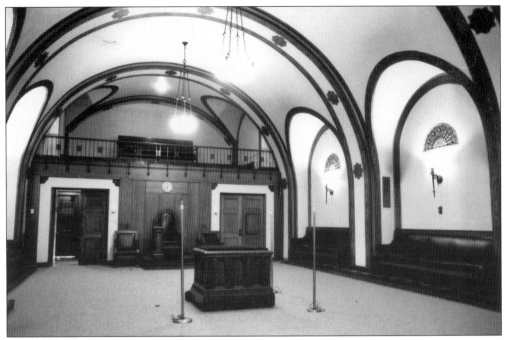

The medieval Romanesque room is the only lodge room in the temple with arched ceilings. It is also the smallest at 29 feet by 53 feet, with seating for 120. Its intimate size helps contribute to a sense of unity, which enhances the brotherliness of the Masons.

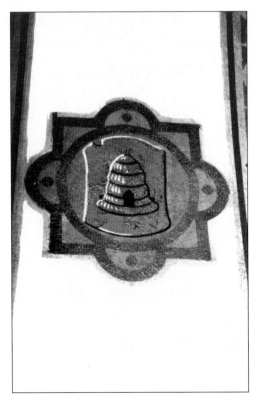

The beehive emblem in the Romanesque room expresses the Masonic symbolism of industry. A carved form of the beehive can also be found on the exterior facade of the building.

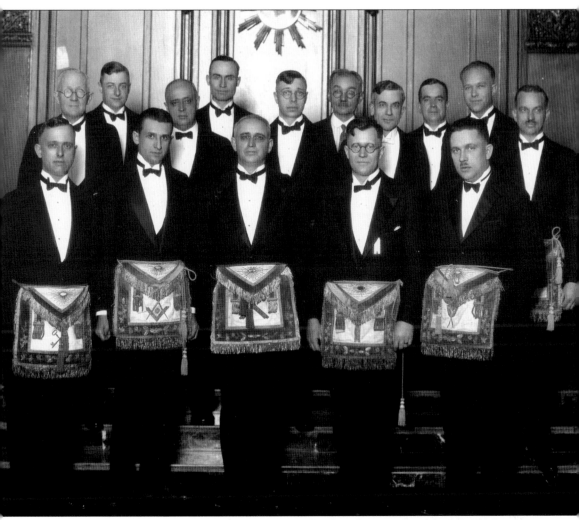

Masons in full regal attire meet in 1927. Proper attire has long been required for formal Masonic ceremonies. Just above their heads can be seen a portion of the traditional G symbol, standing for both geometry and God.

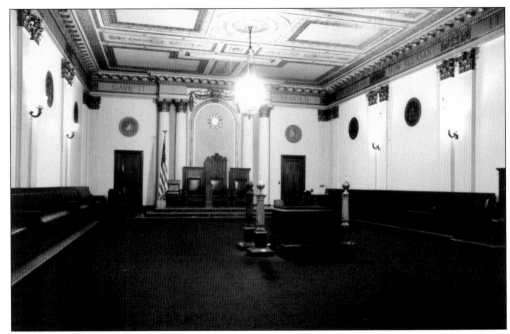

The Corinthian lodge room is pictured. The inscriptions around the ceiling are from the book of Psalms, "Behold how good and how pleasant it is for brothers to dwell together in unity," and from Ecclesiastes, "Then shall the dust return to the earth as it was and the spirit shall return to the God who gave it."

Every lodge room has a staircase leading to a back balcony or mezzanine level. It is a winding staircase divided into sets of three, five, and seven steps. Among other things, they symbolize the three initial degrees of Masonry, the five orders of architecture, and the seven liberal arts.

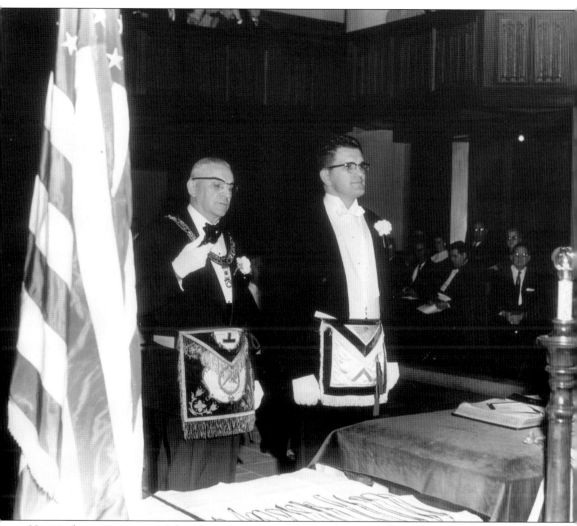

Here is the true purpose of the Masonic temple—Masons dress in full garb for a ritual. This is a full house, with brothers sitting along the walls and filling the balcony.

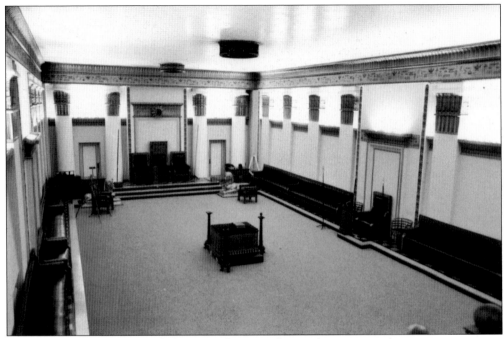

An overview of the Egyptian lodge room shows its classic, almost austere lines.

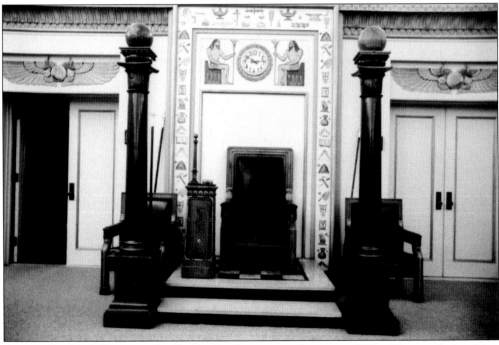

America in the 1920s was enthralled by the then-recent discovery of King Tut's tomb, inspiring the temple's designers to include an Egyptian-themed lodge room. The hieroglyphics are Masonic images interspersed with traditional Egyptian symbols.

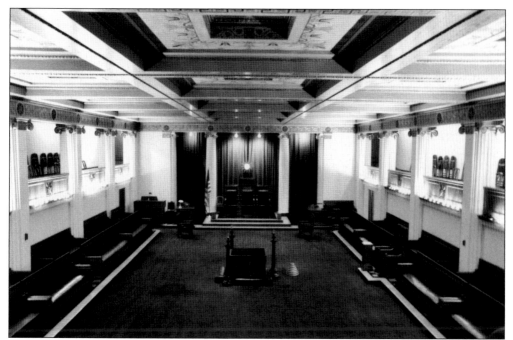

Of all the lodge rooms, the Greek Ionic lodge room became the most popular with the Masons meeting in the building. The largest lodge room, it can accommodate 328 seats.

The Ionic lodge—separate from the Greek Ionic room—has formal, classical lines. The lodge rooms are all basically rectangular but of different dimensions. The Greek Ionic lodge room is the largest, at 40 by 80 feet. The Ionic lodge room is a mere 33 by 60 feet.

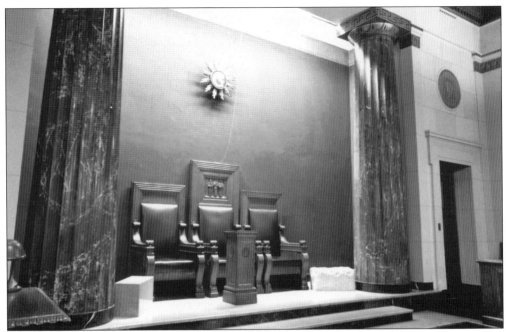

The Greek Doric lodge room is dominated by two huge pillars. Note the two stone blocks, called ashlars, at either side of the chairs. The rough ashlar is symbolic of the newest initiates. The perfect ashlar symbolizes a master Mason prepared for the work of the craft. The Greek Doric lodge room is 34 by 65 feet and has room for 194 seats.

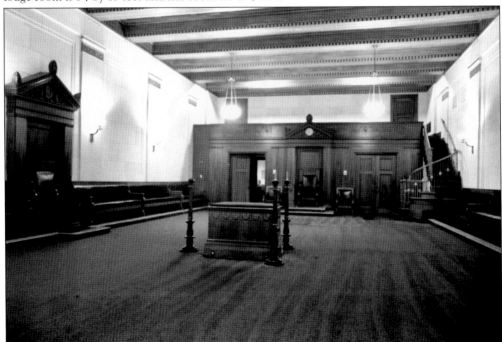

The Greek Doric lodge room is seen from the east. While the staircase to the balcony curves, instead of rising at right angles, it still has the same configuration of stairs—three, five, and seven—as in all the other lodge rooms.

Attention to detail was prodigious, as shown in a banister in the Greek Doric room. Almost no item was too small or mundane to receive an artistic treatment.

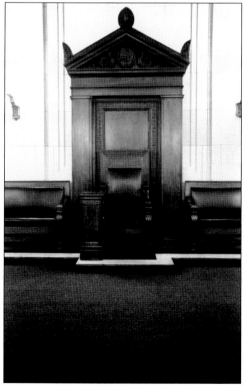

Shown here is the junior warden's chair at the side of the Greek Doric room. The junior warden sits in the south and is responsible for seeing to the rest and refreshment of the lodge.

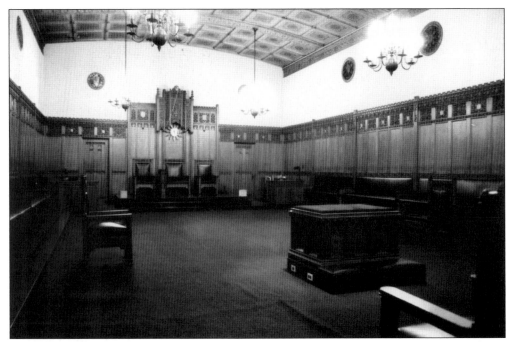

The Tudor lodge room is pictured here. Millions of people have seen this room without realizing it. It served as the courtroom set for the movie *Judgment at Nuremberg*, the 1961 classic film about the Nazi war crimes trial.

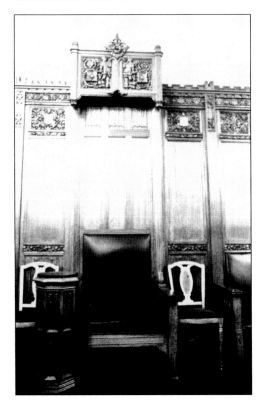

More carvings and wood paneling blend the chair into the wall of the Tudor lodge room.

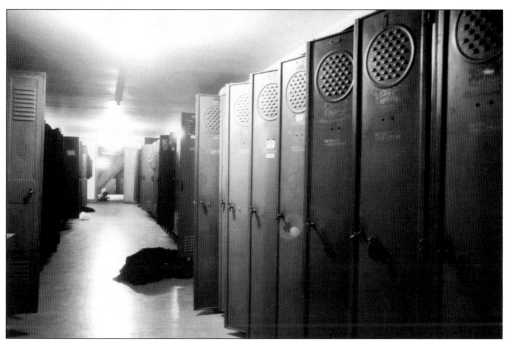

Rows of lockers can be found within the deep interior of the building. Masons stored their regalia, including hats, medals, and coats in the lockers. Rooms of lockers also adjoin the shower rooms in the building. The Commandery locker rooms had a total of 2,000 lockers.

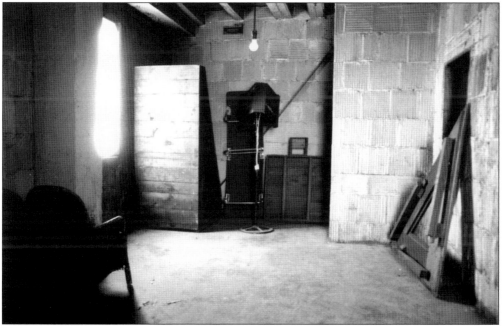

Along with the main rooms of the temple is a vast array of access hallways, utility chambers, and storage rooms. It is possible to go through large areas of the building without setting foot into a public space. Many halls are like secret passageways, hidden between rooms, deepening the aura of mystery in the building.

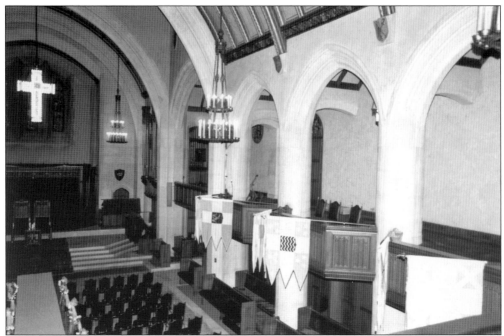

The Commandery Asylum on the third floor is a Gothic cathedral in its own rite. The asylum is the home of the Knights Templar. The high ceilings and stone arches make this one of the most popular rooms for special Masonic ceremonies—as well as weddings.

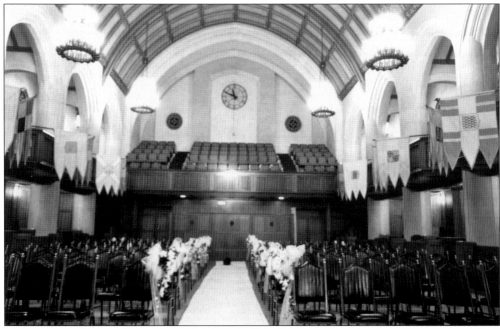

The Commandery Asylum—decorated here with bouquets and a white rug for an approaching wedding—is a replica of the Tower of London, where knights received their charges before setting off on the Crusades. Great attention was paid to detail. Even the stone floor was given a worn look to simulate how the metal-shod feet of the knights would have roughened the stones.

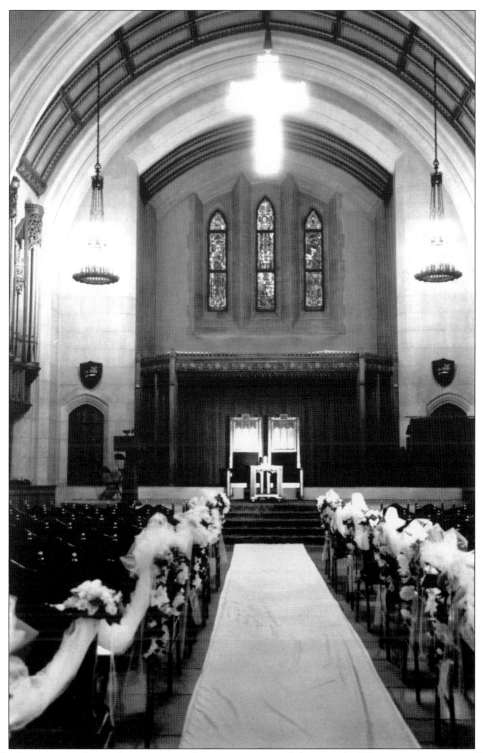

The lit cross in the asylum is set in the exact center of the temple. This is important to the charge of the Templars, as Christian teaching is the center of a Templar's life.

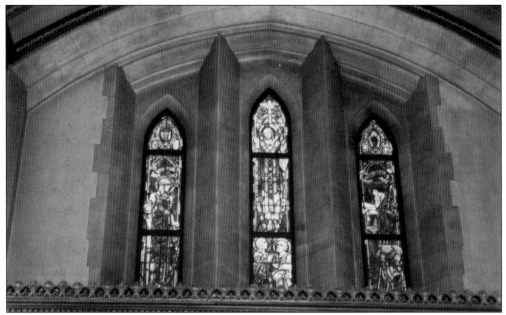

Stained-glass windows, done by the Detroit Art Glass Studio, dominate the asylum. The center depicts the Ascension of Christ, supported by St. John the Apostle and St. John the Baptist. The panel on the right depicts a hermit reading a book, which is symbolic of an expatriate Templar reading the Bible *veritas* (truth) and still searching for the truth. At left is a Templar in full regalia below the familiar words *Semper fidelis* (always faithful).

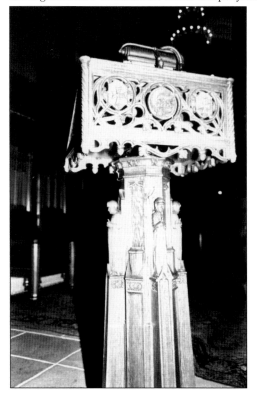

The pulpit in the asylum is made up of fine wood carving. While cost was a concern in creation of the temple, only the finest materials were used, and they were treated with great craftsmanship.

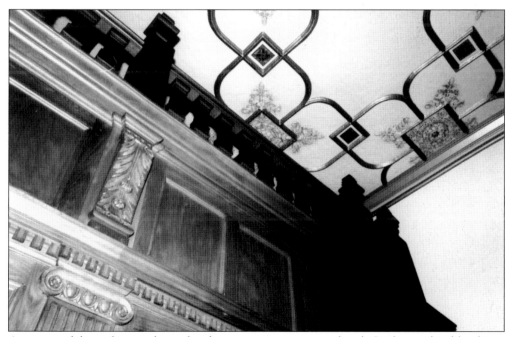

The asylum parlor is decorated in the Tudor tradition with full suits of armor dominating the entrance to the Commandery Archives. These were made in England especially for the temple.

A section of the ceiling in the parlor shows more attention to detail. Craftsmanship like this is rarely found today.

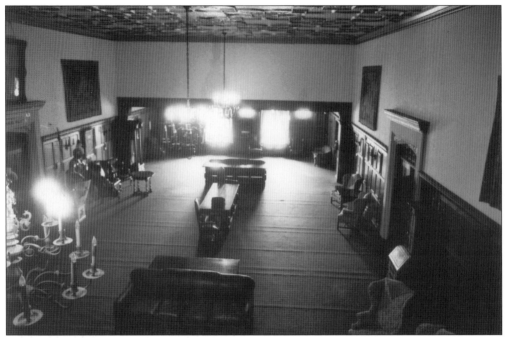

Looking down into the parlor from the balcony, the room, with its oak paneling, has the feel of a stately English manor home.

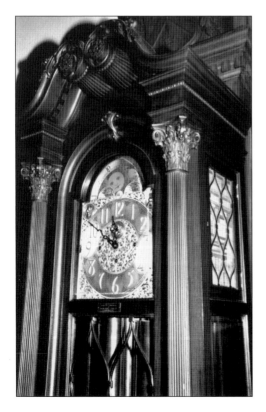

A massive grandfather clock stands stoically in the parlor. In all, furnishings for the building cost nearly $157,740.

A suit of armor from an asylum knight bears the shield with a Templar cross and crown standard *In noc signo vinces* (In this sign I conquer).

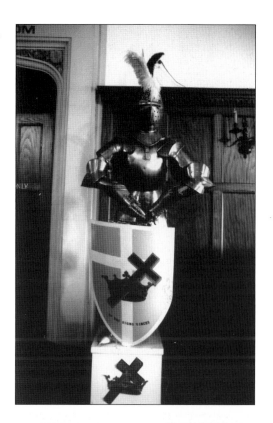

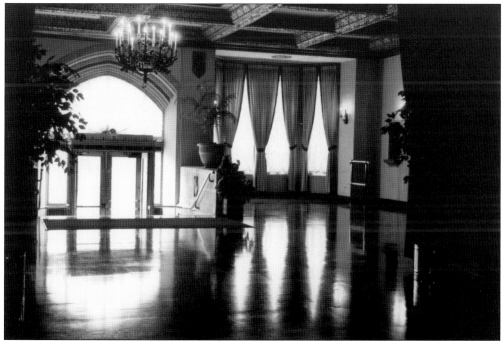

The west lobby of the temple gleams in afternoon sunlight. The dramatic contrast of light and shadow is apparent throughout the building.

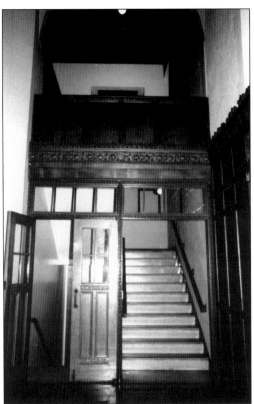

Even staircases take on a dramatic appearance thanks to the fine wood carvings. This is at the west lobby.

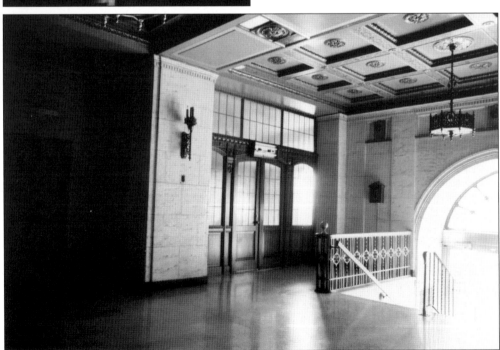

The east lobby is solid and reserved. Note again the detailed ceiling. Special attention was paid to the ceilings. Some were decorated under the direction of Italian artists.

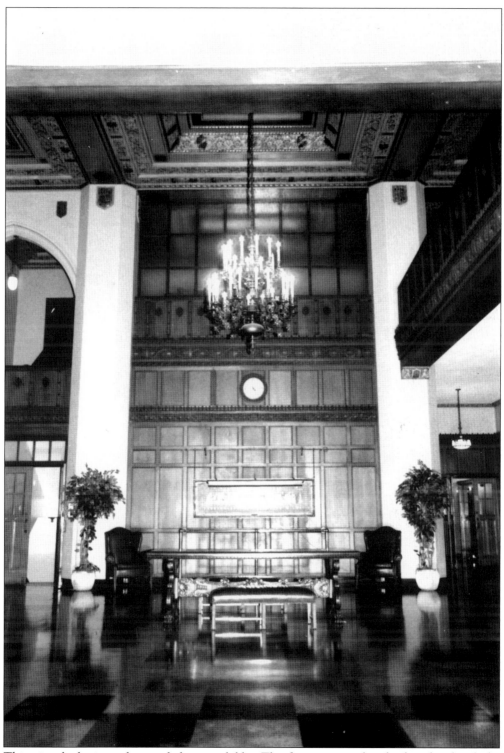

This view looks inward toward the west lobby. The floor repeats the checkered style of tile. Ornate woodwork forms the back wall.

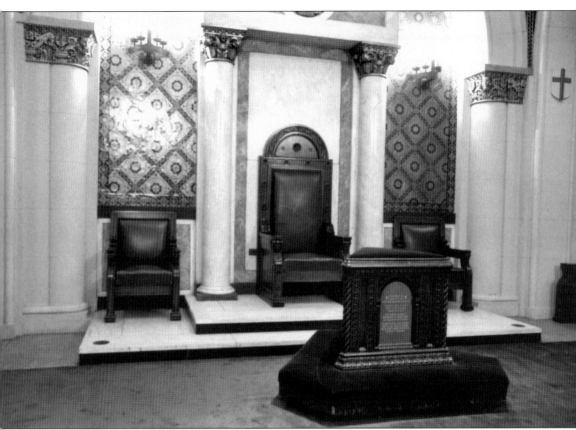

The Red Cross of Constantine room is devoted to the Knights Templar. This romantic and mysterious group attained great wealth and power first by protecting pilgrims going to the Holy Land and later through money handling operations. (They are credited with inventing modern banking.) But in 1312, they were crushed by King Philip IV of France, who likely was envious of their wealth and fearful of their power. The Knights Templar were also known for their generosity and bravery. All Knights Templar are Masons, although not all Masons are Knights Templar.

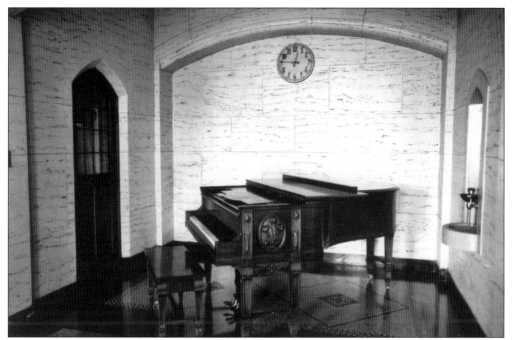

Turn a corner on any floor and one might find a grand piano in an alcove. They provide opportunities for impromptu musical interludes.

The narrow corridor between the walls of a lodge room is pictured. Each lodge room was designed to accommodate dozens of Masons at once. And there are numerous passages connecting rooms while bypassing main corridors.

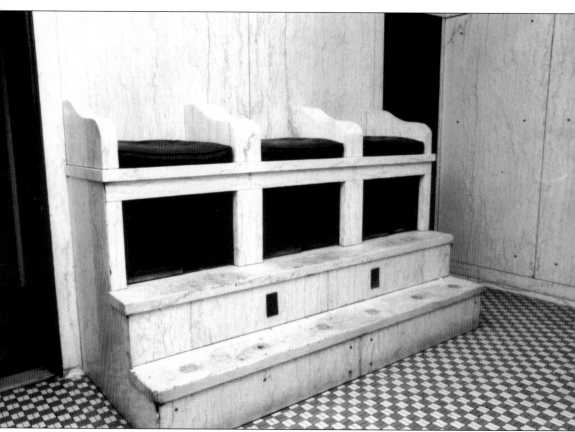

The remnants of marble shoe-shine chairs stand on the Fountain Ballroom level. The walls behind them are made of marble as well. At one time, the temple boasted a three-chair barbershop, a candy/cigar stand, and a rooftop garden, as well as 80 guest rooms that could be rented like hotel rooms.

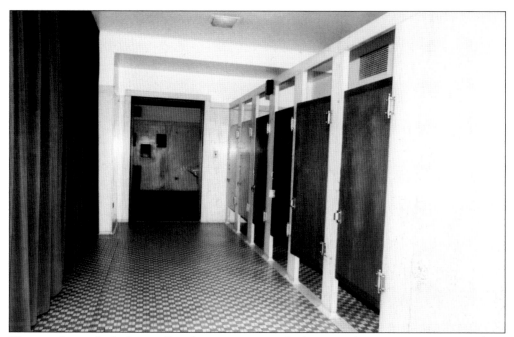

The temple was built for an all-male organization, which required some improvisation in later years when events were held that were open to all. There are no women's bathrooms above the third floor. This one has been converted for women. A line of urinals is hidden behind the curtain at left.

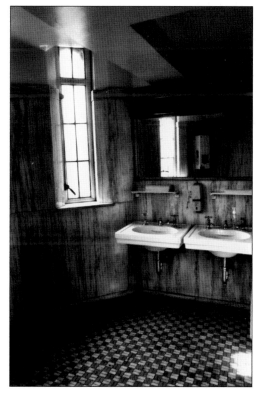

Marble—everywhere—makes each bathroom memorable. Tons of marble was used throughout the buildings. It was supplied by the Vermont Marble Company at a cost of $199,499.

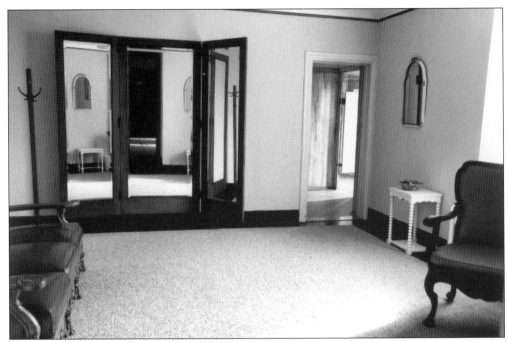

The parlor at a women's bathroom features adjustable full-length mirrors and all the amenities of a modern facility.

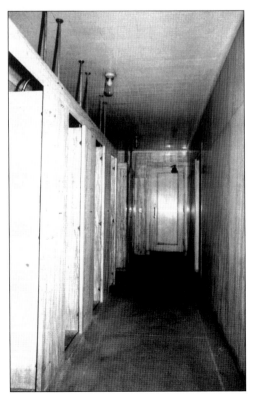

Deep inside the temple is one of the shower rooms that complemented the gymnasium. Everything but the floor and ceiling is made of green-veined marble.

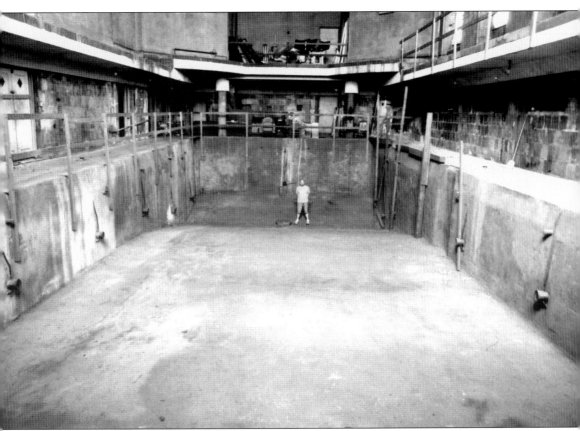

This photograph shows plans that were unfulfilled. The huge swimming pool—or natatorium, as indicted on the original plans—was never finished, another victim of cost and the Great Depression. The pool is situated high above the main floor, which itself is a testament to how incredibly strong the structure of the temple is. Steel trusses 18 feet deep and 78 feet long were used to support the upper floors. The shallow end of the pool is 5 feet deep, and the pool measures 25 by 75 feet. For perspective, the man in the deep end is 5 feet 10 inches tall.

While the pool was never finished, some of the fine detail work was, such as the elaborate art deco ceiling designed by Corrado Parducci. The steel infrastructure of the building was designed to support some 12.7 acres of concrete floor. Even balconies in the lodge rooms have thick concrete floors. One gets an eerie sense of unease walking down some hallways, knowing that just below the few inches of concrete floor is a sheer drop to the floor far below.

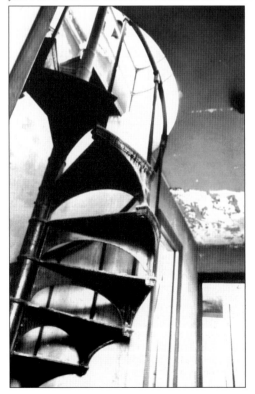

The temple has the mystique of a mysterious building. Details, such as the spiral staircase leading up from the pool area, contribute to it. There are numerous rooms and anterooms throughout the temple, often creating a confusing array. Many are nondescript and bear no special ornamentation.

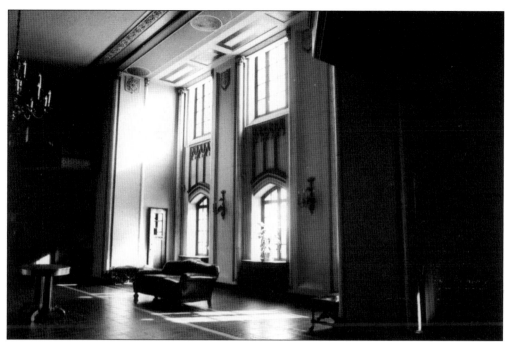

The lobby of a lodge room faces the south side of the building. Lodge rooms stand north of the lobbies, with various rooms to the sides.

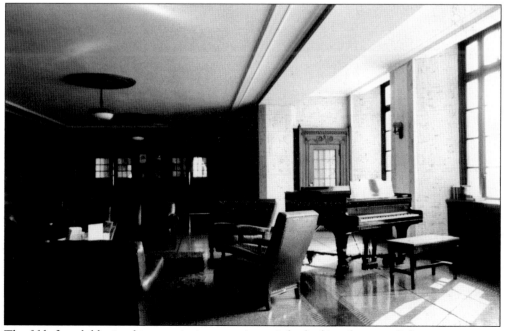

The fifth-floor lobby is a bit more intimate, as it too is bathed in afternoon light.

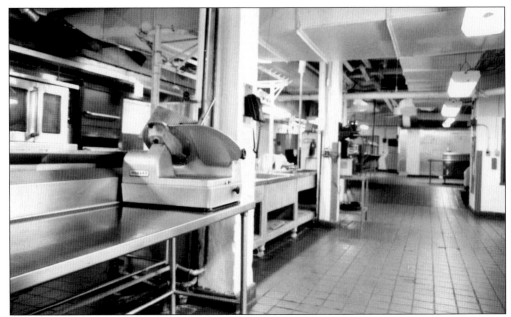

The huge kitchen is prepared to handle the largest crowds that fill the nearby ballrooms. Early promotional material noted, "Months of planning were used in working out the details of the mammoth kitchens of the Temple, which are manned by a steward and chef with years of experience." They have served as many as five dinner rooms, a recreation room, and a public grill.

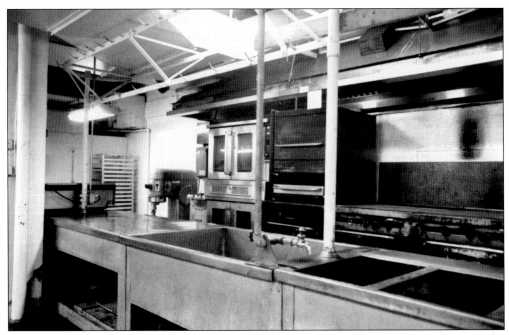

The ballrooms are served by a massive kitchen. An early boast was that all the equipment in the kitchen was "electrically operated, including the ovens, kettles, dish washers, dough mixers, etc. The cooking is all done in aluminum." The kitchen operated its own pastry shop and included two 40-ton ice-making machines.

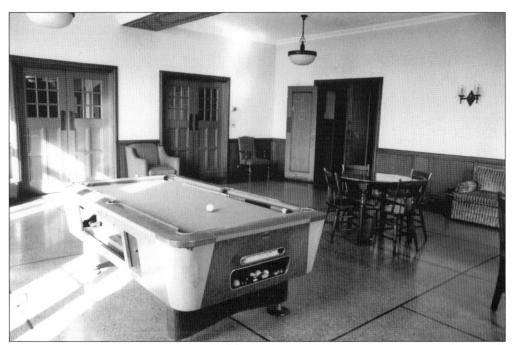

At one time, there were numerous pool tables in the temple for use by members. Today a single table stands in a side room off a lobby as a reminder of those earlier days when the building offered a variety of recreational venues, including a gymnasium and a card room and bowling alleys.

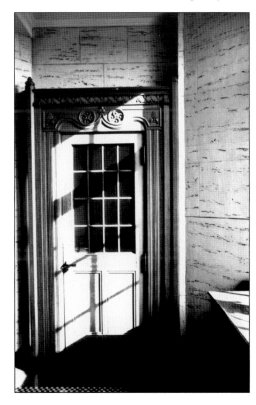

Even a public telephone booth was treated as an artistic expression. Among its many rooms, the temple had 80 guest rooms on the upper floors, and visitors had access to every accommodation, including the private telephone booths. During World War II, soldiers slept and ate here on their way to staging ports on the East Coast.

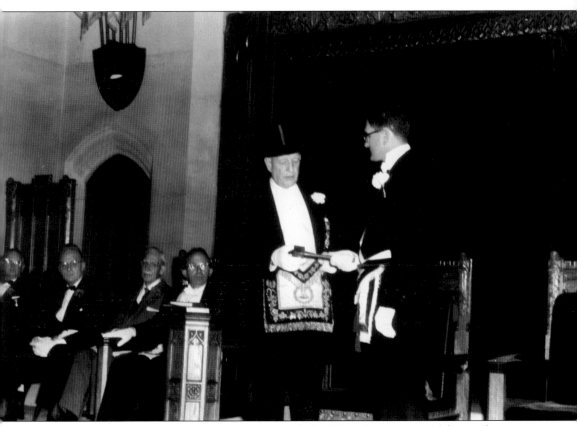

The impressive Commandery Asylum serves as the backdrop for a passing of the gavel ceremony.

Four

DETAILS, DETAILS

The banisters of the staircases leading from the lowest level of the basement to the 14th floor are decorated with square and compass medallions. Somewhere along the way, one of the medallions was installed upside down. Finding it is a challenge.

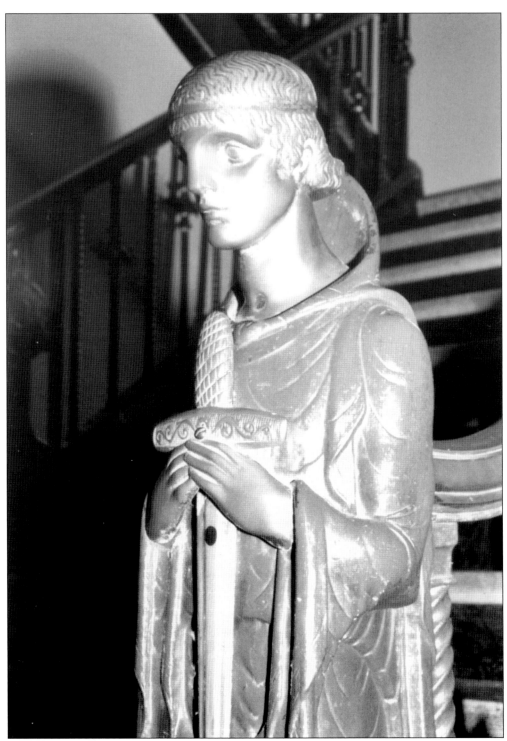

Impressive monks decorate the banisters in the main lobby. The presence of statues of knights, mythical creatures, and human figures offers a curious blend of decorative elements throughout the building.

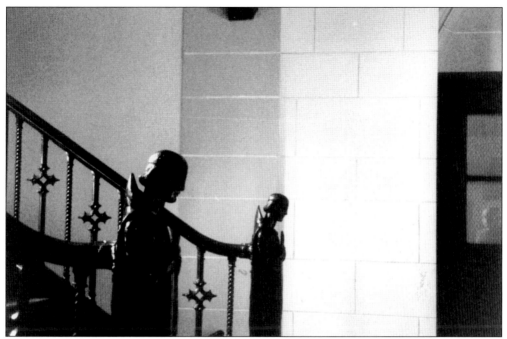

Two monks stand guard at the base of the main lobby banisters.

On several floors, ornate wrought-iron grates cover the air vents. This one is in the Corinthian lodge room. Air circulation was an important issue in the lodge rooms because they have no windows, and doors are closed during rituals. The building was designed before air-conditioning became standard, and to this day, summertime activities are curtailed in the stuffy rooms.

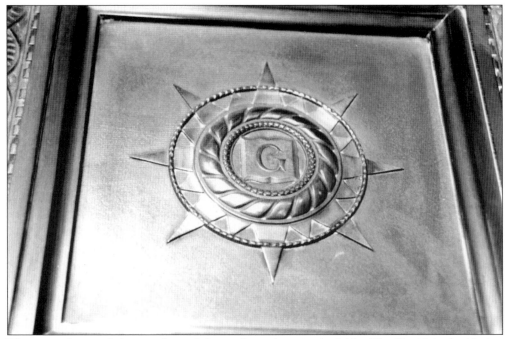

The manual-control elevators have elaborate brass doors in the lobby. The G within the blazing star usually appears within the square and compass and stands for geometry or God. This symbol is repeated throughout the building.

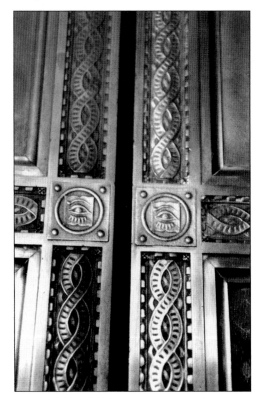

There are six main elevators in the Ritual Tower. The bronze doors incorporate the all-seeing eye, a common Masonic emblem that is present throughout the building.

This elaborately decorated column bears the cross and shield of the Knights Templar. It is in the Red Cross of Constantine room, a small, intimate room.

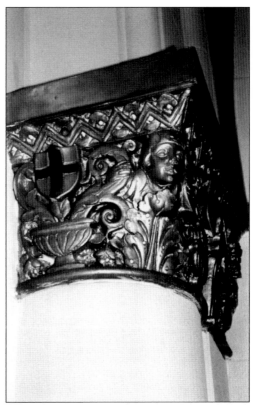

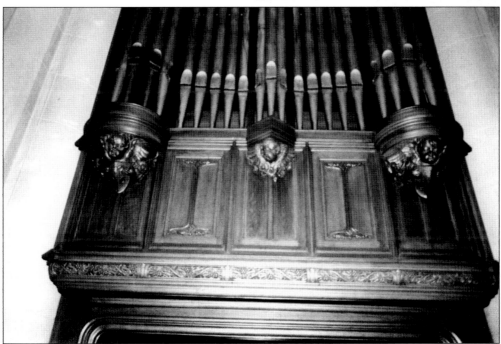

A Skinner Opus 529, one of three pipe organs in the temple, is pictured. The casing is all hand-carved wood.

Hand-carved wood is apparent throughout the building and was done by the Harcus Company of Detroit at a cost of $471,780. In most cases, the center lobby of each floor has two wooden closet-style telephone booths. The telephones have long since been removed.

Complementing the wood carvings, detailed plaster friezes adorn many walls. This example is on the fourth-floor mezzanine.

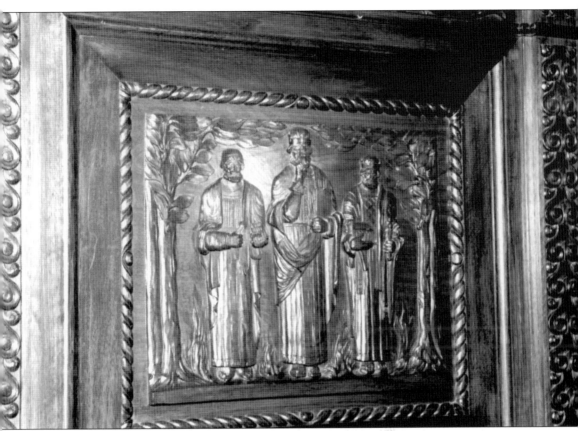

In almost every lodge room, the worshipful master's chair in the east features carvings of Hiram, king of Tyre, King Solomon of Israel, and Hiram Abif, who are the three Grand Masonic pillars symbolic of strength, wisdom, and beauty.

The woodwork in the Tudor lodge room is especially ornate, featuring griffins. Several rooms depict mythological animals.

Examples of finely carved woodwork can be found on doors and wall panels throughout the building.

All of the original furniture in the lodge rooms and most of the furniture in the temple was made specifically for the building and is not found anywhere else.

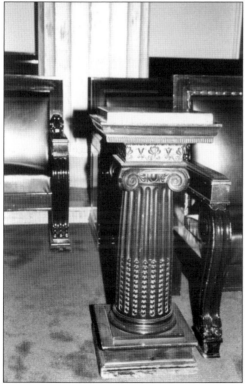

The worshipful master rules the lodge and, occasionally, needs to establish order by a rap of the gavel on a podium like this.

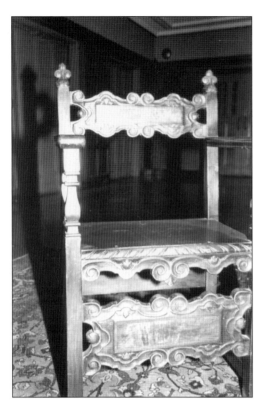

Furniture throughout the building, even in lobbies, was specially made for the temple. "No pains have been spared in providing the finest period furnishings," an early guide to the building boasted.

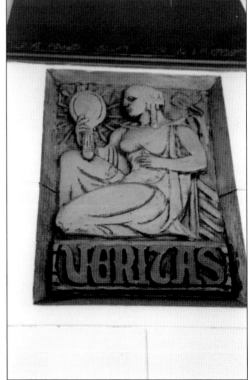

A plaque at the entrance proclaims, *Veritas* (truth). All through the building are reminders of the nobility and symbols of integrity that guide the Masons.

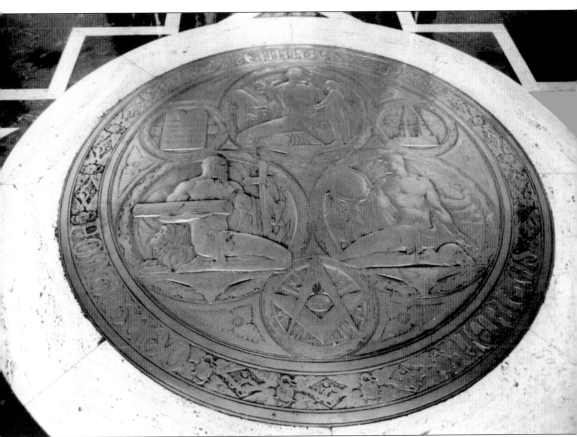

This five-foot-diameter brass seal is the centerpiece of the main lobby floor. It is a casting by Lorenzo Parducci and features the words *fortitudo*, *christos*, and *veritas* (strength, charity, and truth). Over the years, thousands of feet crossing the seal have worn off some of the details, and the seal is now cordoned off with theater rope.

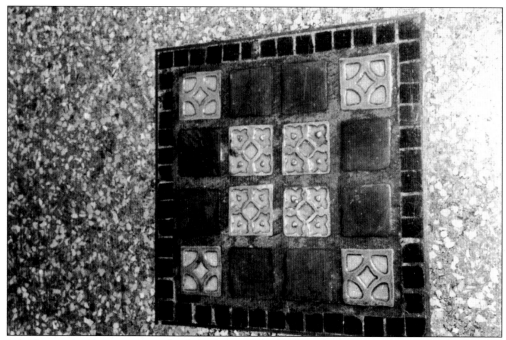

Inlaid ceramic tiles punctuate the floor design. The black and white motif is repeated. The tiles are in remarkably good condition.

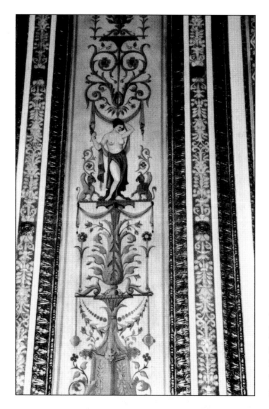

This nude is on the ceiling of the Corinthian lodge room. Contrary to the popular image of a building dedicated to an all-male fraternity, this figure and others like it are the only nude women in the building—ever. The Masons maintain a strict moral code.

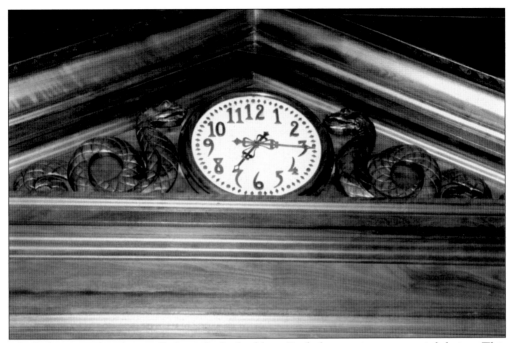

Clocks hang in abundance all through the building. Each features its own special design. This one, flanked by wooden serpents, is in the Doric lodge room.

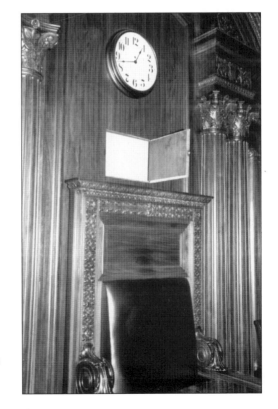

Below the clock in the Corinthian lodge room is a panel that opens to reveal a piece of the Lafayette Temple. The wall behind was taken from the building. The panel door is a remnant from the days when magic lantern slides were used to illustrate Masonic lectures—the PowerPoint presentations of their day.

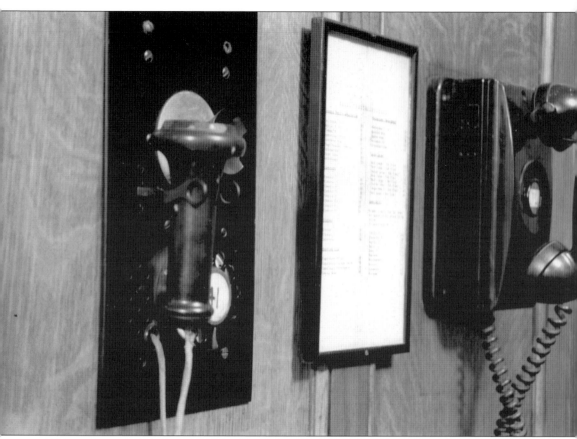

A pair of antique telephones still hangs on a wall long after they have ceased to be functional. They are not the only obsolete technology in the building. Some of the electrical outlets and elevators are direct current, and hand-cranked rheostats still control the lighting level in the lodge rooms.

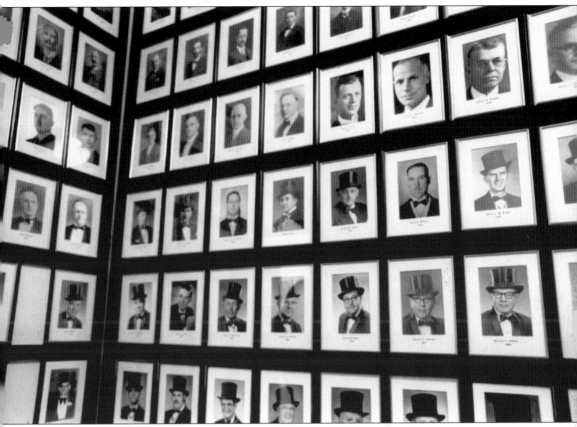

Faces from the past, the past masters wall of Ashlar Lodge holds pictures dating to the 1800s. The display not only shows the leaders of that lodge but also serves as an example of early photography.

The main lobby clock accentuates the ornate designs above.

Woodwork completely encases this clock.

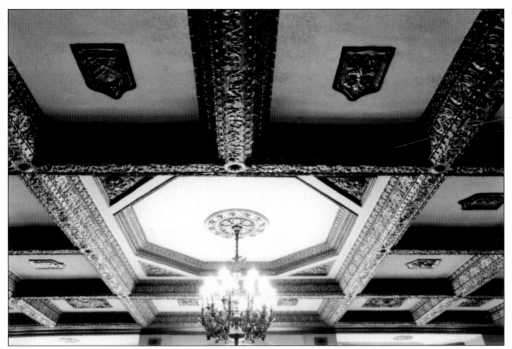

All the light fixtures were custom-made for the temple by the Sterling Bronze Company. At the time it was placed, the order for the fixtures—at $112,412—was the greatest for any single building in the country. This light is in the west lobby.

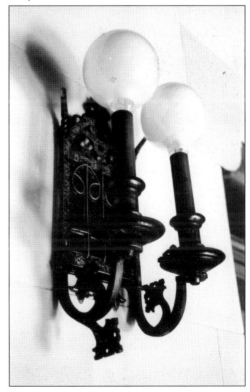

There is a remarkable range of light styles, including sconces.

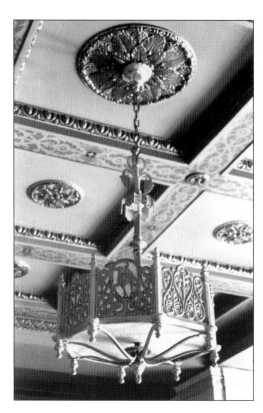

Note the intricate carving on this fixture.

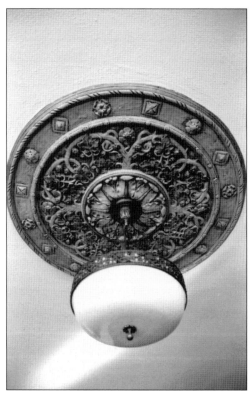

This is a more contemporary design, but it is as if the designers could not settle for a plain glass bowl and added the detailed frame and ceiling medallion.

This fixture is iconic of the combination of simplicity and elegance characteristic of much of the temple detail.

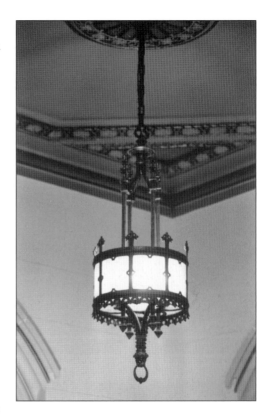

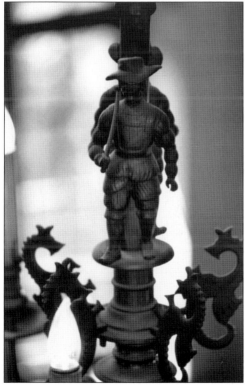

This brass soldier, cast by Corrado Parducci, stands on top of a chandelier on the fourth floor. Like so many other features in the building, it is not easily visible from any vantage point.

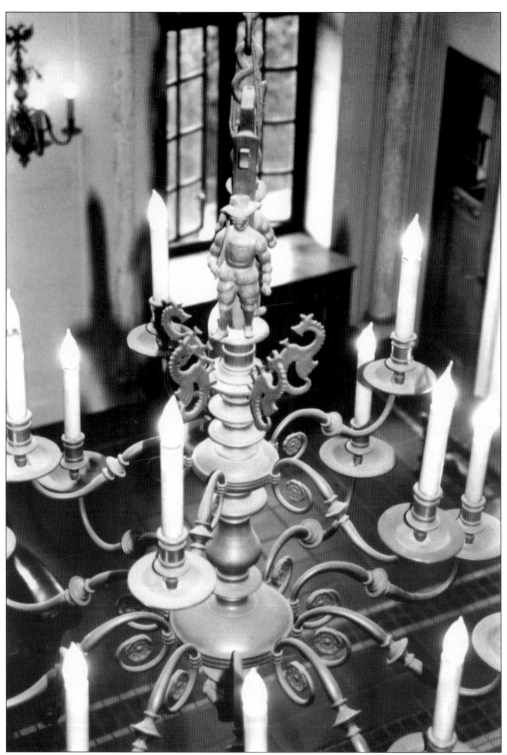

The chandelier in full shows the placement of the soldier. High above the floor and several feet from the balcony railing, it is easy to overlook this little treasure.

112

Five

THE NEIGHBORHOOD

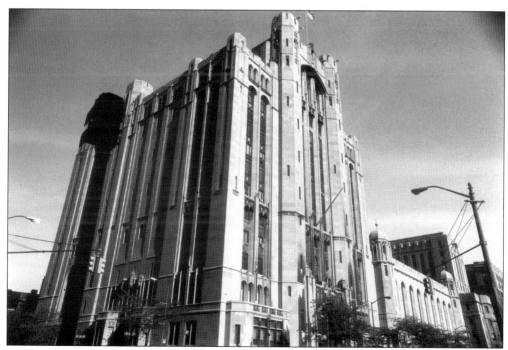

Still majestic, the temple dominates its neighborhood just northwest of downtown Detroit.

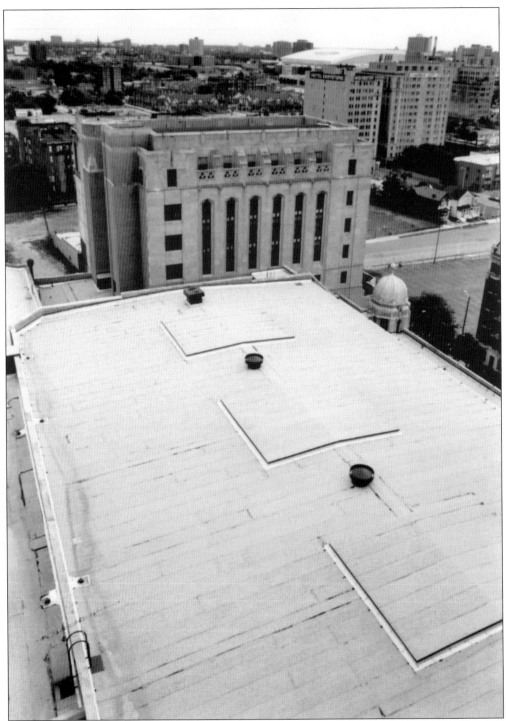

The roof areas of the temple cover more than two acres. Originally the temple was designed in the shape of a gavel, with the Ritual Tower forming the head and the auditorium area forming the handle. That changed when the Shriners' section of the building to the east was added to the design.

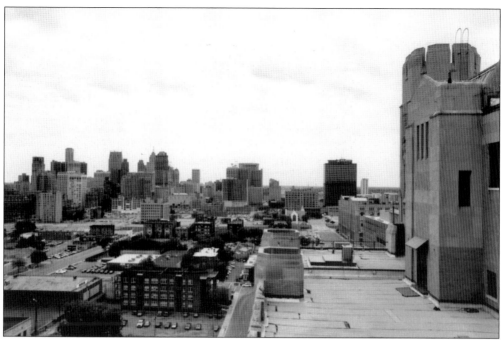

This view looks toward downtown from one of the rooftop balconies. There are several such perches that have been used for parties by hearty Masons not afraid of heights.

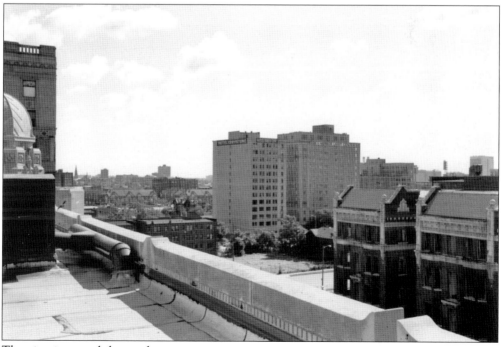

The view is toward the southeast.

From one of the highest points on the temple, the view to the south is memorable. On the horizon to the right is Renaissance Center, which is on the Detroit riverfront.

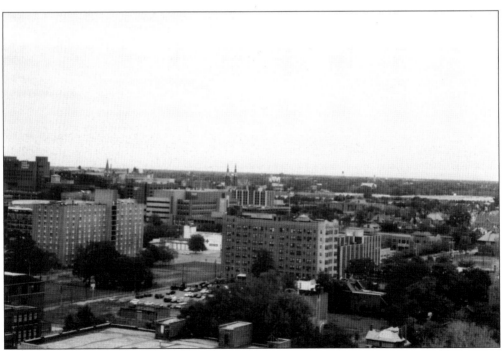

Looking east, the twin spires of Sweetest Heart of St. Mary Church are barely visible piercing the horizon line near the center.

The view directly north is toward one of Detroit's other great architectural landmarks—the Fisher Building, about a mile away. The Fisher Building was designed by noted architect Albert Kahn. Contrary to what many believe, Kahn had no hand in designing the Masonic temple.

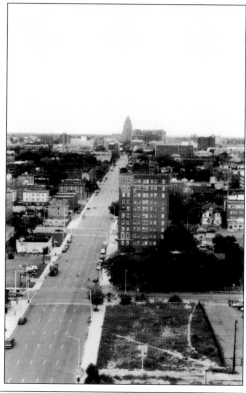

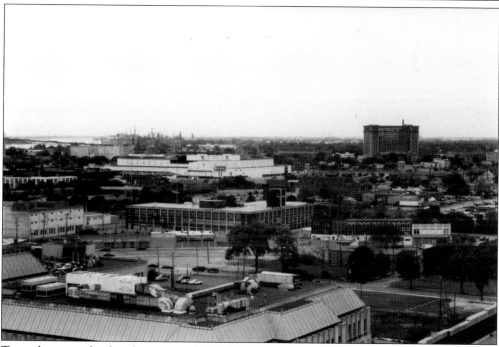

Two other great landmarks present themselves to the southwest. Rising in the distance is the old Michigan Central Railroad Station. The low, wide white structure in the center is old Tiger Stadium. Both structures are vacant these days.

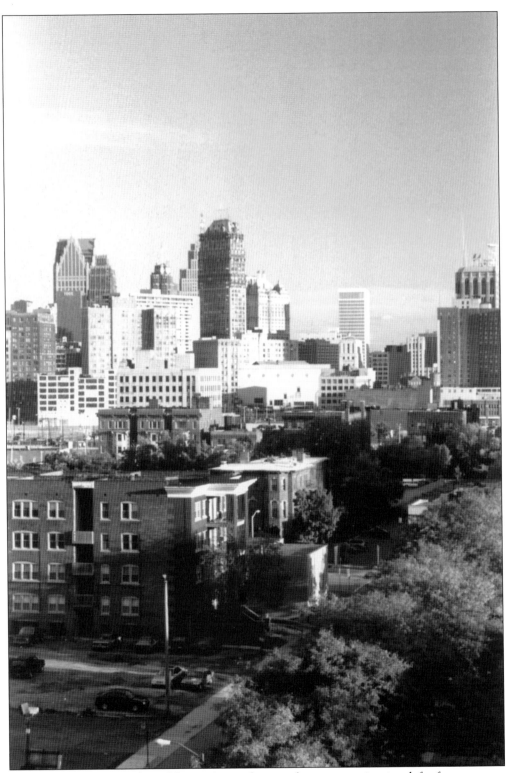

The Book Building, another of the city's most historical structures, rises just left of center.

A tangle of trees gives an ethereal quality to the exterior of the temple, as seen from Cass Park, across the street. The location of the park actually figured into the selection of the site for the temple as it provides a broad staging area that does not compete with the great walls of the temple—trees notwithstanding.

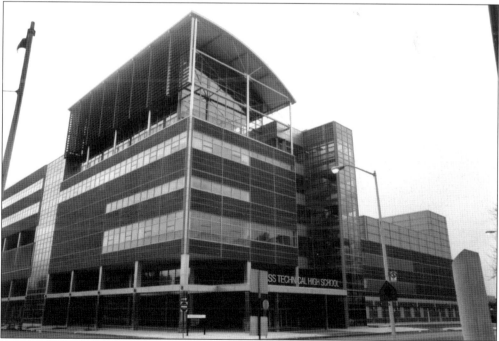

A close view of Cass Technical High School reveals its gleaming modern lines. The modern lines of the school stand in sharp contrast to the classic design of the temple.

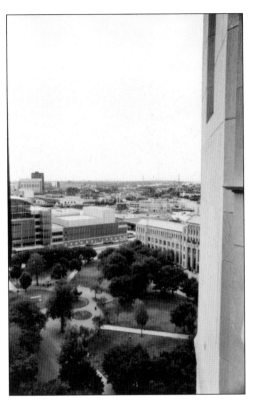

Cass Park, with its formal lines, stretches out below. At one time, the park was covered with stately elm trees, but in the 1950s and 1960s, they fell victim to Dutch elm disease, a disease that destroyed millions of trees in the area. Only a few isolated survivors remain.

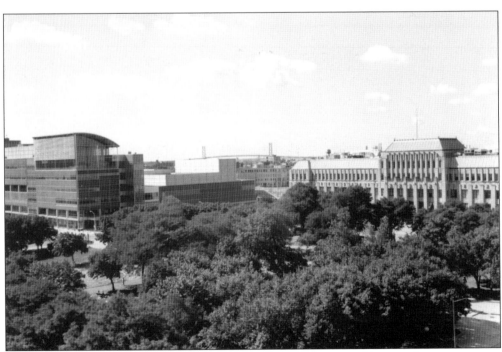

The Metropolitan Center of High Technology, on the right, is visible over the trees next to Cass Park.

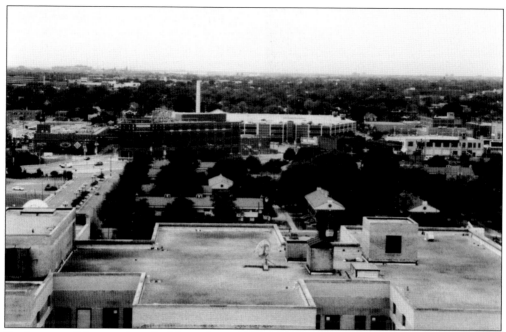

To the west of the temple is the Motor City Casino, which opened in 1999 in the former Wagner Baking Company building on Temple and Grand River Streets. The Wagner Baking Company building was opened in 1915, and the original exterior details, including the building's name stone, were retained when Motor City moved in.

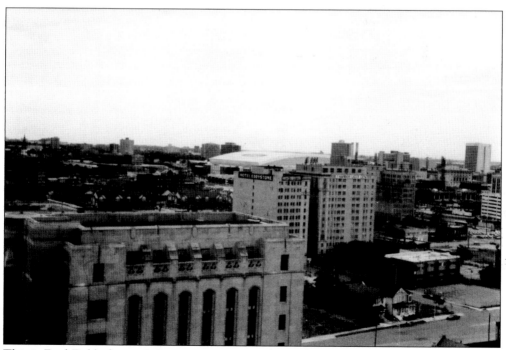

This is Ford Field, the city's newest sports venue, beyond the Hotel Eddystone. The Shriners' section of the temple is in the foreground.

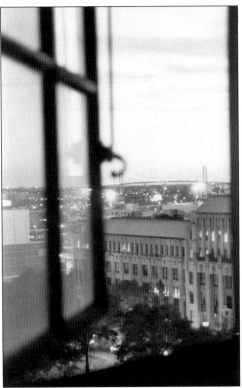

Like a view out of history, a temple window reveals the city at sunset. The Ambassador Bridge is outlined with beads of light. Not quite downtown, the temple is on the fringe of the central part of the city.

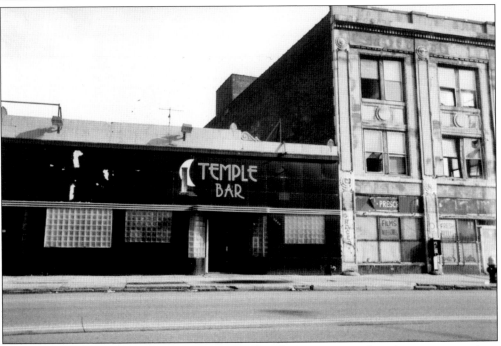

The Temple Bar is a landmark of sorts. It is faced with ceramic-coated steel, in a pure art deco style. It is conveniently located near the temple, which appeals to some since no alcohol is allowed in the lodge rooms.

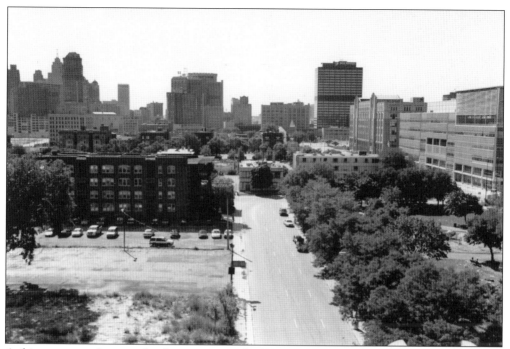

A fair amount of vacant land now surrounds the temple. However, residential development projects have been bringing some new life to the area.

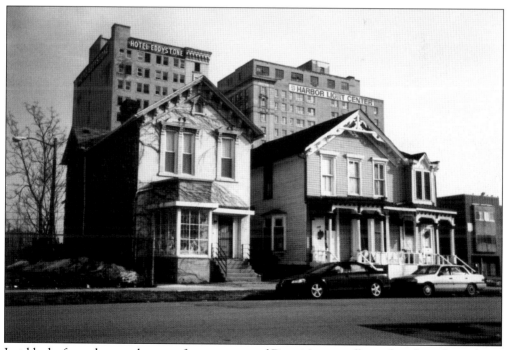

Just blocks from the temple, some fine remnants of Detroit's past still stand, such as these classic houses. These are similar to the type of houses that stood on the site where the temple was built.

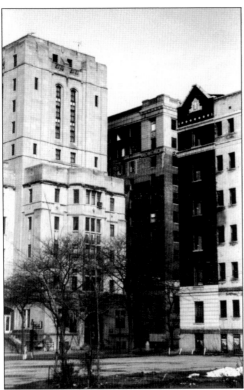

The dilemma of the temple is evident in this view, which actually features three separate buildings. The temple is at left. The abandoned Hotel Fort Wayne is at center, and an abandoned apartment house is at right. Only the temple retains its dignified appearance.

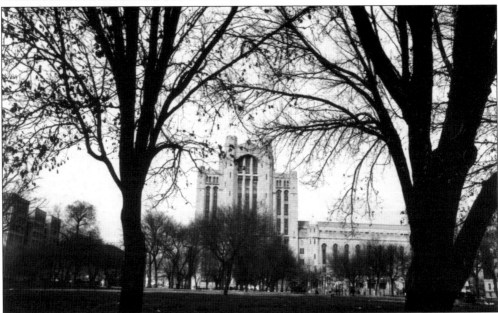

Framed by imposing trees, the temple rises over Cass Park. Both are usually taken for granted by most people who do not know their significance or place in Detroit's history. Cass Park is one of the larger downtown area green spaces, but because it is removed from the main flow of traffic, it is largely overlooked. Even when there are events at the temple, parking, not the park, is the focus of attention.

No, that is not Lewis Cass standing above Cass Park. Although the park was named after Michigan's territorial governor, the statue is of the great Scottish poet Robert Burns. It was erected in 1920 by the Detroit Burns Club and is a replica of a statute that stands in Burns's hometown of Ayr, Scotland.

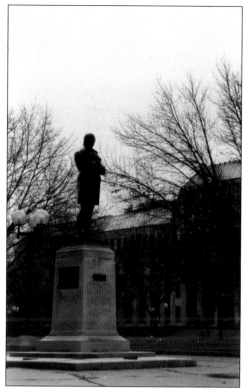

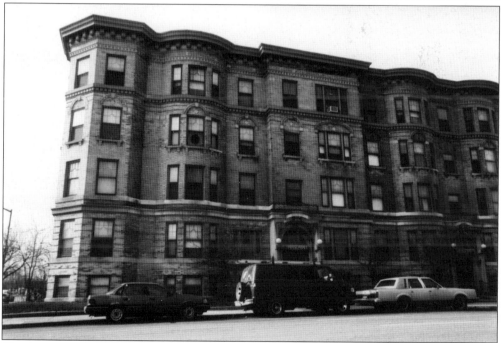

The Ansonia apartment building stands across the street from the temple. It retains some of the regal elegance of Detroit's great days when fabulous buildings were being built just prior to the Great Depression.

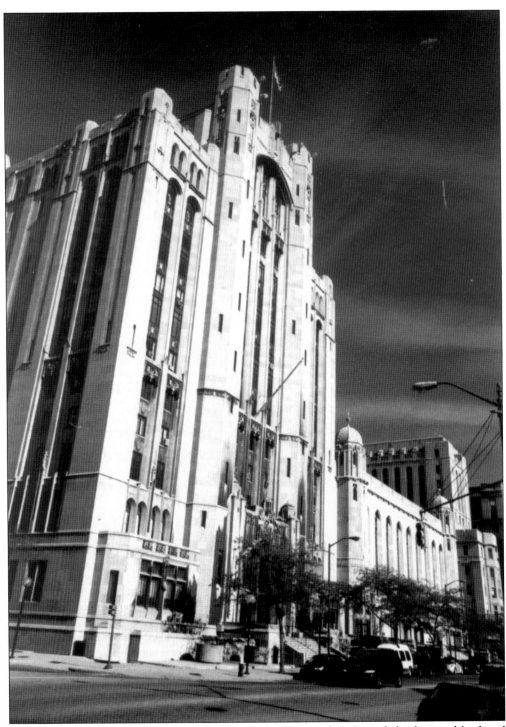

The temple stands as an island to much of the area around it. But while the neighborhood has suffered from urban blight, there are still indications that things are improving as new construction moves in and gentrification of the area just to the north continues. What the future holds, however, for the neighborhood and the temple is uncertain.

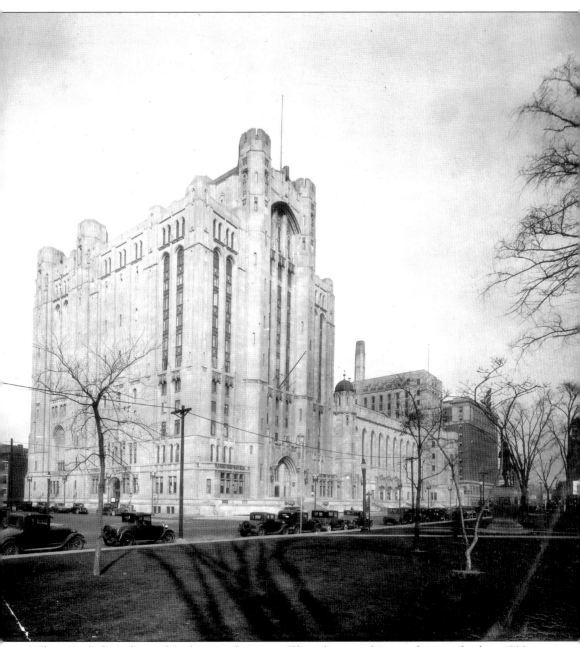

The temple has changed little over the years. This photograph was taken in the late 1920s shortly after it opened. It looks essentially the same today, except for the presence of the classic old cars parked in front. For some 80 years, the temple has stood as a symbol of Masonry and its dedication to brotherhood and integrity. It is a fitting physical tribute to the fine aspects of Masonry. (Photograph courtesy of the Burton Historical Collection, Detroit Public Library.)

ACROSS AMERICA, PEOPLE ARE DISCOVERING SOMETHING WONDERFUL. *THEIR HERITAGE.*

Arcadia Publishing is the leading local history publisher in the United States. With more than 3,000 titles in print and hundreds of new titles released every year, Arcadia has extensive specialized experience chronicling the history of communities and celebrating America's hidden stories, bringing to life the people, places, and events from the past. To discover the history of other communities across the nation, please visit:

www.arcadiapublishing.com

Customized search tools allow you to find regional history books about the town where you grew up, the cities where your friends and family live, the town where your parents met, or even that retirement spot you've been dreaming about.